GHOSTS OF OLD WILMINGTON

GHOSTS OF OLD WILMINGTON

JOHN HIRCHAK

Haunted America

Published by Haunted America
A Division of The History Press
Charleston, SC 29403
www.historypress.net

Cover image: Price Gause House, built in 1860 upon the bluff known as Gallows Hill, the location of one of Wilmington's gallows poles. *Photo by John Hirchak.*

Cover design and illustration by Marshall Hudson.

All images courtesy of the author unless otherwise noted.

First published 2006
Second printing 2008
Third printing 2009
Fourth printing 2010
Fifth printing 2011
Sixth printing 2012

Manufactured in the United States

ISBN 978.1.59629.150.8

Library of Congress Cataloging-in-Publication Data
Hirchak, John.
Ghosts of old Wilmington / John Hirchak.
p. cm.
ISBN 1-59629-150-8 (alk. paper)
1. Ghosts--North Carolina--Wilmington. I. Title.
BF1472.U6H57 2006
133.109756'27--dc22
2006013546

Notice: The information in this book is true and complete to the best of our knowledge. It is offered without guarantee on the part of the author or The History Press. The author and The History Press disclaim all liability in connection with the use of this book.

For Miles, my favorite peanut

CONTENTS

ACKNOWLEDGEMENTS

First and foremost I must thank the guides who perform the Ghost Walk of Old Wilmington and the Haunted Pub Crawl: Denise Ward, Lewis Musser, Suesan Sullivan, Mike Hartle (with a special thank you for his grammatical prowess, quick wit and willingness to read the endless dribble), John Henry Scott, Geri Spaur, Scott Brooks, Stacy Edmunds, Tara Noland and Damond Nelson. Thank you for living on the frontlines of these stories every night.

I must also tip my hat to the Black Cat Shoppe for helping to keep the spirit of Wilmington's haunted, magical and mystical past alive.

I also owe a debt of gratitude to the families, business owners, volunteers and associates affiliated with not only the haunted sites included here, but the many others I promise to include in the next book. Thank you for sharing so much of your lives with me.

Not enough can be said about the wonderful people at the Cape Fear Coast Convention and Visitors Bureau. You do more than you are ever given credit for.

Thank you to Beverly Tetterton and Joseph Sheppard for direction, assistance and conversation. I am humbled by your knowledge of Wilmington's history.

I would also like to thank the good people at The History Press for approaching me with this idea. I would especially like to thank William C. Cleveland. I appreciate you responding to all three thousand emails I sent you. Your patience helped quell at least some of this writer's panic.

I would be remiss if I failed to mention Glenn Kashin, Stuart Wilding, Frank Kramer, Mark Klein, Craig Simmons and Mark and Ed Feeley. Even with the craziness that is New Orleans, you managed to provide invaluable suggestions, encouragement and laughter.

A big thank you and lots of love to Corie McInnis, for being the best-looking dead girl in the family, and for all your help with this endeavor.

To Lindsay Miller, who so eagerly wants to participate! It's encouraging to see such an intelligent, beautiful young woman like yourself strive to frighten children. Thanks for always letting me read to you (and I am sorry about the nightmares).

A lifelong thank you is due to my mother, Anne Hirchak, for reading to me when I was young, and for giving me a passion for the written word.

To my son, Miles, for his patience and understanding in allowing me to write this book when he would have much preferred we throw the baseball or go for a bike ride. Thanks for telling everyone you want to be the "King of the Ghost Walk" when you grow up, but it will have to wait until you receive your doctorate!

And finally, to my wife, Kim. Thank you for everything. Your ideas, advice, inspiration, patience and support mean the world to me. I can't imagine how empty my life would be without us having ever met.

Introduction

Though it was the beach that first brought my wife, Kim Hirchak, to Wilmington in 1978, it was her interest in the paranormal that led her to the banks of the Cape Fear River, into the heart of the Historic District. Since then she has amassed a heap of notes on the various ghosts that haunt the Port City. So in 1996, when she first brought up the idea of starting a Ghost Walk, it seemed like the logical progression to one of her driving passions. Apparently I responded with an encouraging word.

However, feeling Wilmington wasn't quite ready for a ghost walk tour, she put it on the back burner for a few years. Then again, in 1999, she brought up the idea. Again, according to her, I offered words of encouragement (I really don't remember). And so armed with the knowledge that I too believed this was possible, the journey began.

My function was to do a little historical research behind these legends (though I want to stress, I am no historian), to write the scripts and to market the tour. She was to do all the rest. As

fate would have it, she broke her leg. She turned pleadingly to me, convincing me that after three hundred rewrites I knew the material well enough to do the walk. I reluctantly agreed, but only until her bones healed!

Discovering something new about yourself is either tragic or wonderful. In this case, it was wonderful. As shy as I often feel, I learned that I love to entertain people. At the same moment, Kim learned that she doesn't have the strong vocal chords required to overcome Wilmington's incessant ambient noises. She also recognized that the day-to-day tedium of the business better suited my strengths, and that sums up her business acumen. She knows how to make things work, and is willing to give up control to get things done.

And so over the years I have become the face of the Ghost Walk of Old Wilmington and the Haunted Pub Crawl. But in the end, this is her baby! It always has been, and always will be. I hope this book captures the feeling of the legend and lore she so truly cherishes. It took twenty-one years to do the initial research, and another seven years of entertaining the masses to try and perfect the mood of each story. I'm just grateful Kim invited me aboard for the ride.

A friend of mine, John Henry Scott, once told me how everything in his life has been an accident, from his days playing the Jazz Fest in New Orleans to his radio, television and film roles. When his autobiography is published it will be entitled *My Accidental Life*.

At times, I too feel that my life has been a series of accidents, some more fortunate than others. I have learned, and hope to pass down to my beautiful son (borrowing a thought from Robert Frost), that if you take the path less traveled by, it will often make all the difference.

The Children of the Latimer House

The bustle in a house
the morning after death
is solemnest of industries
enacted upon earth
The sweeping up the heart
the putting love away
we shall not want to use again
until eternity
—Emily Dickinson

On March 7, 1840, the last spike was driven into the 162 mile-long Wilmington-Weldon Railroad, the longest railroad line in the world at the time. In addition to a modern railroad, Wilmington was also home to a major seaport situated on the banks of the sinuous Cape Fear River. At the same time, Wilmington was the largest city in North Carolina, so it's no surprise that young

entrepreneurs from across the country flocked to the Port City. It was into this bustling, thriving environment that a young man by the name of Zebulon Latimer arrived.

After establishing himself in Wilmington, and following a proper courting period, Zebulon married Elizabeth Savage. Elizabeth had married well, for Zebulon was a hardworking and industrious person, and by 1850 he owned a dry goods business, was a stockholder in one of the Wilmington railroad lines, was involved in the naval stores business and was part owner of a river wharf.

With their wealth, Zebulon and Elizabeth Latimer built their ten thousand square foot Italianate revival dream home in 1852. The four-story home is brick construction with a tan stucco hard-coat. The exterior is finished with intricate stone, iron and wood detailing. On the south side of the home is a beautiful piazza with a metal canopy roof and elegant cast-iron supports that depict a grape arbor.

Other ironwork worth mentioning is the beautiful woven cast-iron fence that partially surrounds the home. Originally the home had wood fencing; however, at some later date the family decided an iron fence would better suit the grandeur of the structure. As a matter of convenience the family took a carriage ride to Oakdale Cemetery and removed the old iron fencing that surrounded the Latimer and Savage family plots. They then had it installed on the front and left side of the home. They also employed the two family plot gates, replete with family names and dates, installing them on the garden wall in the rear of the home.

Now a ten thousand square foot home can feel mighty lonely with just two people in it. So Zebulon and Elizabeth decided to fill it with nine children. Unfortunately five of these children died before reaching their fifth birthday.

Zebulon died in 1881, and Elizabeth in 1904. William Latimer, one of three surviving sons, inherited the home and remained there until his death in 1923. After William's death, a nephew, Herbert Latimer Jr., inherited the home. One of the terms of the inheritance was that William's widow, Margaret Meares Latimer, would remain in the home until her death.

In 1922 an artist named Elisabeth Chant arrived in Wilmington and took a room at the Orton Hotel on Front Street. She was an eccentric, carefree soul who exuded great confidence, and upon her arrival she had a huge impact on the local art community. She took on many students, including North Carolina's greatest artist, Claude Howell. She was a unique character, dressing eclectically in clothes of her own making. In 1930, as a guest of Margaret Meares Latimer, she moved into the Latimer House. By then she was in frail mental health. She kept her suitcase packed because she felt she was soon to embark on a long journey. She was also consumed with thoughts of the spiritual world. Her desire to communicate with these spirits occupied much of her time.

Elisabeth Chant died in 1947, and Margaret Meares Latimer followed in 1956. Herbert Latimer, no longer having an interest in the property, sold it to the Lower Cape Fear Historical Society (LCFHS) in 1963.

The LCFHS currently maintains the home as a "living" museum. Essentially the home can be experienced in a manner much as the Latimers once did. With few restrictions, guests are free to roam the house at will and to admire an abundant assortment of antiques, many of which are original Latimer family holdings. The "living" museum evolves from season to season (and in some respects almost daily). One day the home may be preparing for a Victorian wedding; another day a Victorian funeral. But many claim the Latimer home is alive to more than just social functions. The home is very much alive with some pretty active spirits.

Are you surprised? Having bore witness to so much death, being surrounded with cemetery fencing and having played host to a spirit conjurer, of course it's haunted!

The first documented occurrence takes place in 1948. Mrs. Love, a close friend of the Latimer family, was driving past the home one March afternoon. On her way by she noticed Empie Latimer, Zebulon and Elizabeth's grandson, stepping out of the front door. The two were lifelong friends, and so upon noticing each other they exchanged an enthusiastic wave of the hand. But immediately Mrs. Love felt out

of sorts. Something was wrong, but what was it? As she pulled into her driveway two blocks away it occurred to her. Empie Latimer had died the preceding January.

Another strange occurrence involves employee and volunteer's eyeglasses. For over forty years, since the LCFHS first acquired the home, dozens and dozens of pairs of glasses have gone missing. From desk drawers and shirt pockets, from purses and briefcases, the eyeglasses vanish, never to be found again!

In 1981 there was a fire in the home. It started in the basement and quickly worked its way up the hollow cavity of the walls. And though it resulted in only moderate structural damage, the smoke damage was pretty extensive. All house furnishings had to be removed in order to be refurbished. Contractors were then brought in to begin repairing the physical damage, and immediately they began reporting strange noises coming from the fourth floor. It was the unmistakable sound of furniture being dragged from room to room; the staccato squelching of spindle-legged fixtures bouncing across the rough-hewn wood floor, reverberating down the open stairwell, penetrating the entire home. Like fingernails being dragged across a chalkboard, the clatter was chilling.

Impossible, the staff argued, for all the home's furnishings had been removed to be reconditioned. There was no furniture on the fourth floor! And yet, since the fire this horrific sound is still periodically heard. The fourth floor was where the Latimer children's bedrooms were located.

The Latimers were voracious readers, and many of the books now found in the home were originally owned by the family. In 1998 a docent was reorganizing one of the bookshelves in the southeast parlor when she ran across a very narrow, discrete selection, tucked away between two larger books. She gently slipped free the slender book and gingerly opened the well-worn pages. To her surprise she found it was a book of poetry by Emily Dickinson. As she perused the fragile pages she discovered the book to be a first edition. Immediately recognizing the value she brought the book to a senior staff member's office.

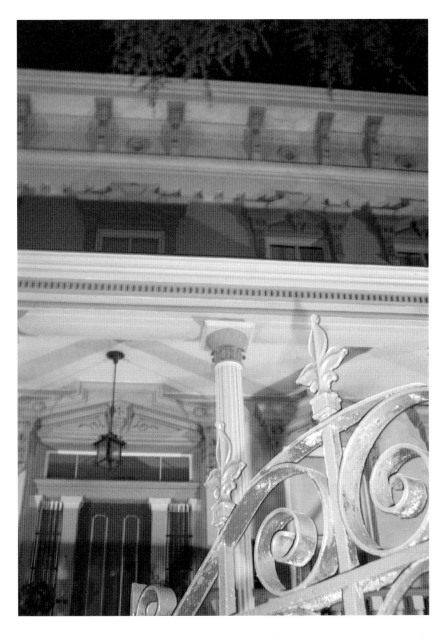

The old cemetery fencing that surrounds the Italianate Latimer House is only a part of the reason the home retains so many wayward spirits.

In the big scheme of the Latimer museum the book was of little consequence. And some would argue in a sad reflection of our declining culture, local museums like the Latimer are notoriously short on funds. So at the time selling the book in order to raise some much needed capital seemed like a brilliant idea. So the staff member placed the book on a chair behind her, next to a wicker basket full of yarn, and told the docent as soon as she was done typing out some correspondence she would make a few calls to try and ascertain its value. She then returned to her typing and the docent to the front parlor.

A few minutes later the docent called out that she had found another book. As the staff member swiveled around in her chair and peeked through the French doors to see the docent's discovery, she noticed something peculiar out of the corner of her eye. The book of poetry and the wicker basket of yarn were levitating five feet off the ground. The woman gasped, jumping to her feet, and backed against the office wall. She watched in abject horror as the trembling basket overturned, dumping its contents onto the floor. And then both objects slammed down with such a force the docent thought someone had taken a violent fall. Rushing into the back offices she found the convulsing staff member.

"Are you all right?" the worried docent asked.

"I don't know," the other woman replied. "I'm not really sure."

After explaining what had transpired, the two decided it was probably best to put the book back on its shelf and forget about ever selling it. Obviously one of the Latimers still has a strong attachment to it.

And then there is the basement.

The basement of a home is a mystical place, especially for children. It's a place that on one hand demands exploration, while on the other hand is a convenient hideout for monsters and demons. Most adults experience a feeling of dread upon entering a cellar and rarely dawdle. Perhaps it's a fear of small, confined, poorly lit places or the similarity between a basement and a grave. There must be a reason the characters in the most frightening horror movies always end up

there. But whatever it is that makes a basement so unnerving, the Latimer home possesses it, so to speak.

The house is wired with an extensive, state-of-the-art security system. In the evening the last one out of the home exits through the basement, where the alarm's activation panel is located. And if everything is just right, those fortunate enough may experience one of the more elusive occurrences in the home: the freshly smoldering odor of pipe tobacco! It only happens at night, after the activation code is entered, and never when more than one person is present. That's an awful lot of criteria for a spectral event involving what may have been Zebulon's after-dinner smoking room!

In the summer of 2000 a volunteer worker was alone in the basement, vacuuming the tearoom carpet. After completing the tearoom he began backing his way out into the hallway. At the doorway he stole a glance behind him to make sure no obstructions were in his way. With nothing to impede him he turned and began backing out of the room, pushing and pulling the whirring vacuum. Two steps later he painfully backed into something hard.

The initial shock of the blow sent waves of pain up his middle back, and as he winced in surprise, he turned to discover a large high-backed oak chair directly behind him. The chair blocked his entire exit from the tearoom. Perhaps the pain from walking into the unforgiving chair dulled his thinking. Though he knew it wasn't there a second earlier, he thought perhaps he had overlooked it.

He twisted back around and put the vacuum in an upright position, turning it off with the toe of his shoe. When he turned back around to move the chair, a matter of a second or two later, it was no longer there! The chair was now fifteen feet away, sitting in the middle of the hallway!

He let out a scream and took off running, up the back staircase, bursting into the historians' offices.

"Did someone move the chair?" he began shouting.

The startled historians were so frightened that they had to peel themselves off the ceiling. But still there was a look of pity offered to this poor, deranged volunteer.

"Did you move the chair?" he plied nervously to one of the historians.

"I'm not sure what you're talking about," she stammered.

"Someone moved a chair! In the basement," he continued muttering. "Did you move the chair?" he asked, turning to another historian.

"It wasn't me. You've been the only one in the basement all morning. No one else has been down there."

Without uttering another word he turned and ran out the back door. He called in sick the rest of the week. He has yet to venture back into the basement.

Another strange occurrence takes place in the hallway between the tearoom and the kitchen. A stifling, offensive odor will suddenly and briefly assault guests as they move from one room to the next. It is a putrid stench that causes one's eyes to tear and the bile in one's throat to rise. The only saving grace is that this vile smell is there one moment and gone the next. No matter how hard even the most masochistic guest tries to recapture that obnoxious stink, it cannot be done. It lasts for only one breath. Those who have experienced it say it is the smell of death—and death was indeed nearby!

Directly across the hall from the tearoom is the kitchen. Nine out of ten guests who tour the home and ask if it is haunted do so upon entering the kitchen. In the autumn of 2000 a university professor had just wrapped up some research in the third floor archives. He was walking through the basement on his way to his car, which was parked in the rear parking lot. As he passed the kitchen he overheard several guests questioning the docent about food preparation in the mid-nineteenth century. The professor, being a little familiar with the subject, entered the room in order to share some of his knowledge. He politely cleared his throat, and as the group turned towards him they found a crazed looking, trembling man before them. The professor was nearly frozen still. His skin was ashen and he began to shiver, feeling suddenly cold.

"There's death in this room!" he chanted, backing out into the hallway. "There's death in this room," he muttered again, as he turned and ran out of the home.

As strange as this reaction may seem, many people have shared a similar experience. Those most sensitive to the spirit world say the room is thick with death. But where does this strong, undeniable manifestation come from?

In the center of the kitchen rests an enormous cypress preparation table. The table was originally constructed in the house, and it is so large and heavy it would have to be cut into several sections in order to be removed from the room. It was on this cypress monstrosity that the family meals were prepared: the dicing of the fresh vegetables, the spicing of the juicy lamb and pork chops and the mixing of the ingredients for the freshly baked pecan and apple pies. It was upon this same table where the Latimers' daily sustenance was prepared that the cold, naked bodies of several of their dead children rested.

This was all very common before the advent of funeral parlors. The basement would have been the coolest floor in the house, so it would have been an ideal place to store a body. The large cypress table would have made an excellent surface in order to prepare the child for burial. After being placed on the table, someone would have gently washed the small, lifeless remains and then covered them with a sheet or small blanket. Then, as the process of decomposition began, the body would be left alone, sometimes overnight in the darkened room, to await the delivery of an undersized child's coffin.

Upstairs, the mourning process would have begun. Reams of black cloth would have been unfurled and draped across the windows and mirrors. And all this time, the child waited, alone, in the cold, dimly lit kitchen, covered by a smothering cloth. What was the spirit of a newly dead four-year-old child expected to do?

So when visitors to the Latimer house say they can feel death in the kitchen, be assured it is there. And it's in more than just the kitchen. For if you catch yourself standing out front of the house late at night, staring at the darkened windows, you should not be surprised to find the face of a child staring back at you!

Missing glasses, moving chairs, levitating books!

Child's play?

Perhaps!

GALLUS MEG, PROPRIETOR

In the early 1700s Wilmington was known as New Liverpool. Many of the streets in downtown Wilmington are named after streets in Liverpool, England, and like old Liverpool, New Liverpool was a rough and rowdy seaport.

Pirates the likes of Blackbeard, Stede Bonnet, Calico Jack, Anne Bonny, Mary Reed, Charles Vane and George Lowther plied the waters in and around the Cape Fear region. Unlike Hollywood's romanticized version, piracy was a hard, violent lifestyle and with few exceptions, rather short. Battle, shipwreck, scurvy, tropical disease and tavern brawls took their toll.

Aboard ship, pirates lived by a code that included punishments like keelhauling. This amounted to tying off a pirate's wrists with a long, heavy rope. The rope was dragged beneath the ship to the other side and then tied to the pirate's ankles. Then, like a human trinket on a rope bracelet, the pirate was hauled overboard and pulled from one side of the ship to the other. The razor-sharp barnacles on the underbelly of the vessel would shred the mate apart.

If you were lucky enough to survive all this lunacy, you always risked capture. There your story would end with a quick drop and a sudden stop, for piracy was punishable by hanging.

In New Liverpool many an innocent man began his seafaring days after being shanghaied. An enticing woman or a fresh bottle of rum would lure the hapless victims. They'd be slipped drinks spiked with knockout drops, later referred to as Mickey Finns. After being robbed, the unconscious lout would be dumped off on a seagoing vessel. They would awaken to find they had "signed on" as crewmembers.

Sea-weary sailors arrived daily in New Liverpool. Upon arrival they would wander the alleyways and seek out the "dive" keepers— pub owners who emulated the infamous "Barbary Coast" of San Francisco's harbor. The area of town they gravitated to was the half-block between Market and Dock Streets, and the river and Front Streets. The area was known as Paradise Alley, so named because of the bawdy wenches who dangled from the alley's windows, soliciting sailors as they wandered by.

Along Paradise Alley was a dive known as the Blue Post. Inside the Blue Post was a bartender by the name of Meg—Gallus Meg. "Gallus" is an old derivative of the word "gallows," and Meg earned this nickname by her propensity to lift unruly sailors by their throats, thus giving the appearance they were dangling from a gallows!

Needless to say, Gallus Meg was a brute of a woman. She stood over six feet tall and weighed 350 pounds. Her mammoth arms were like ham hocks, the leathered flesh smothered in tattoos depicting her travels during her sailor days. She ruled the Blue Post with an iron fist.

When someone in the Blue Post got out of hand, perhaps knifing a paying customer or harassing the "ladies" who worked in the private rooms at the back of the pub, Gallus would breach the bar with her enormous mass, grab the offender by the throat and carry the waggling wretch out of the pub. Once in the alley she would slam the miscreant to the ground and then curl her enormous, bulbous fists. With forearms like pile drivers she would beat the scamp senseless and then, for good measure, she would rip off one of his ears with her teeth.

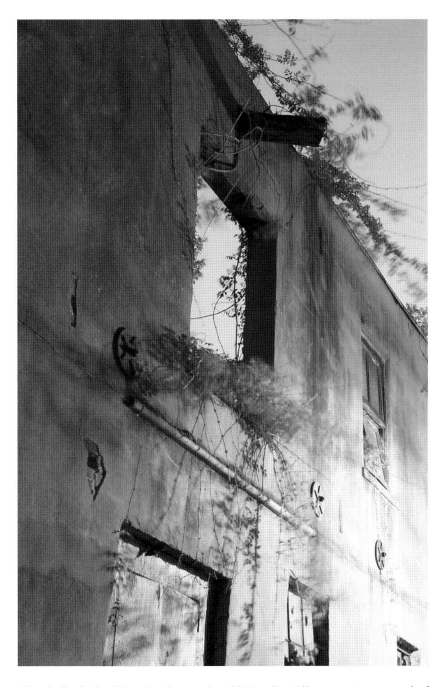

The shell of a building that litters the old Paradise Alley stomping ground of the bar wench, Gallus Meg.

With the bloodied ear still clenched between her teeth she would walk back into the Blue Post and spit it into a pickling jar that sat atop her bar. The jar was filled with many ears, as well as several fingers, all of which she had taken in the past.

The ghost of Gallus Meg still haunts the old Paradise Alley. She has been encountered in the Water Street Restaurant. Those who have worked there over the last sixteen years have claimed to see her ghost, as have many, many patrons.

The ghost of Gallus Meg is seen in the back of the restaurant, more specifically in the ladies room. However, she is only seen by men, who say they accidentally stumbled into the wrong restroom, only to find this rather large woman coming toward their throats with her flabby digits as they go barreling out of there, many never to return to the eatery again.

Nobody knows what happened to the jar of ears, but it's probably safe to say that sailors on their first visit to the Blue Post left there either one ear shy, or perhaps victims of the other crime that took place in there: with a very, very upset stomach, having eaten the chewiest pig snout they ever set their teeth into.

THE ORTON'S MISSING TWO–THIRDS OF A MAN

The Orton was a grand hotel! Opening in the spring of 1888, it was a five-story brick behemoth featuring over one hundred rooms. Billed as the finest and most luxurious hotel in North Carolina, the prominent façade seemed to substantiate this claim. The imposing entrance had a two-story, second floor verandah that stretched the entire width of the structure. The center of the verandah had an elliptical recess, while on either end of the broad porch were lush conservatories, billowing with rare tropical plants and flowers.

The interior was even more luxurious. The lobby was finished with imported stone and ornately carved hardwoods. An elegant rotunda greeted guests, while an Otis elevator serviced all five floors. The hotel was heated by steam and had electric lights throughout. Many of the rooms included such amenities as parlors, open fireplaces and bathrooms. The dining room menu advertised the South's finest cuisine (we're not talking pig's feet and hominy).

The basement of the hotel featured a barbershop, bakery, kitchen and steam laundry. There was also a billiard room and bar. It was a

magnificent spectacle, but even the best-built structure is susceptible to the elements.

At 12:20 on the morning of January 21, 1949, the terrible clanging of fire bells rang out. Guests were summoned from their beds as flames quickly lurched up the hotel staircase and elevator shaft. Those on the second floor raced to the verandah, jumping to the safety of the street below. Those in the upper rooms gathered on the fifth floor and anxiously awaited rescue. With the aid of Wilmington's longest aerial ladder, the fifth floor was cleared. The hotel manager proudly announced that everyone was accounted for. In a fire that amounted to over $1 million damage, it appeared there was not a single fatality.

And then a report was filed. While huddled atop the fifth floor awaiting rescue, guests witnessed a dazed man wandering the smoke choked hallway. They called out to the man, but at each shout he wandered deeper into the billowing gray gloom. But all guests were accounted for, so who could he have been?

At the time of the fire a gentleman who kept a room at the Orton was on his deathbed at James Walker Memorial Hospital. The morning before the fire the dying man's brother, J.R. Mallard, arrived at the hospital after an all-night rail journey. After sitting by his dying brother's side all that day, and with nowhere else to go, the weary Mr. Mallard decided to spend the evening in his brother's room, unbeknownst to the front desk clerk. Mr. Mallard must have fallen into a deep sleep, only to awaken to the cries of "Fire!" several hours later. Unfamiliar with the hotel, he stumbled out into the smoke choked hallway, and at perhaps the exact moment of his brother's death, Mr. Mallard became trapped in a violent conflagration. Why did he walk away each time the guests called out to him? Could the spirit of his newly deceased brother have played a part?

Despite the half-million gallons of water used to fight the fire, it still took two weeks for the sight to cool enough to be inspected. With the collapse of the roof and five stories of brick into the basement, the rubble pile was immense. Yet one of the first items retrieved was a March of Dimes collection box, completely unscathed. But it wasn't

until twenty-seven days after the fire that the body of J.R. Mallard was found, facedown on a charred mattress. The awful stench of the badly burned and decomposing body is what led investigators to find the remains.

The day Mallard's body was recovered, news surfaced of a second possible victim. William Stephens, a twenty-five-year-old tugboat hand, was seen entering the Orton on the night of the fire, and he had not been seen since. As common as it was for rough sea hands to disappear on a weeklong drinking binge, it's hard to imagine how it could have taken over three weeks before someone thought to inquire about their deckhand's whereabouts.

One month after the initial fire, workmen, using a dragline shovel, unearthed a portion of Stephens's skull. Over the course of two days, one-third of his body was unearthed, though whatever became of the other two-thirds remains a mystery.

As an unregistered guest, what could William Stephens have been doing in the Orton? Police suspect he was simply visiting someone in their room. But then why didn't the person he was visiting report him missing at the time of the fire? Could his presence have been deemed embarrassing?

After the fire all that remained of the once grand Orton was the basement. In time the area was rebuilt, and the basement opened again as a pub, billiard hall and barbershop. It was at the Orton Pool Room, in 1953, where Willie Mosconi set a world record by sinking 365 pool balls in a row. Those present said there appeared to be a guiding force there that day. Pool balls that teetered on the edge of a pocket, with no remaining inertia, would suddenly tumble in. It was magical to watch, many witnesses commented. Magical indeed!

By 1953 unusual occurrences began emerging from the depths of the cellar. Those who descended into the Orton Barbershop claimed there was a strange presence in the basement room. Personal objects began to disappear, and toilets seemed to flush of their own accord.

However, by 1970 the basement fell into almost complete disuse. There wasn't much interest in retreating into a dark haunted basement

for a haircut or a drink when you had a wonderfully sunny main street to walk upon. It wasn't until the 1980s that the basement pub again came into popularity.

The basement was renovated into two separate pubs. Bessie's, the larger of the two, included a billiard room featuring Willie Mosconi's record-breaking pool table. The second, smaller space, which was originally the barbershop, opened as General Longstreet's. Longstreet's was a private bar, part owned by the actor Tom Berenger. General Longstreet's was named after a character he played in the movie *Gettysburg*.

After opening, the owners, managers, bartenders and wait staff begin to experience an uneasy feeling whenever alone in the basement. Some people reported hearing a muffled male voice, mumbling from some distant point in the cellar. It was impossible to make out individual words, but regardless of what was actually said, it was quite unsettling. It became even more troubling after some of the braver staff began seeking out the origin of this voice, only to find that no matter which direction they walked, the voice always seemed to drift away, much as the smoldering J.R. Mallard had done on the night of the fire.

Running water was a constant theme at both pubs. Staff was often confronted with self-flushing toilets and slop sink faucets that would begin flowing on their own. Could this compunction with water be a sign from the two men who died in the great Orton fire, as a way to soothe their souls from the searing pain of the fire?

Early one evening a patron of Bessie's was on her way back from the ladies room in the back of the bar. On her way past "Stephen's Corner," a small alcove tucked away in the rear of the cellar, she noticed an attractive man sitting alone. A brief conversation ensued, lasting less than a minute, before the young man, who introduced himself as Bill, excused himself, explaining he had to meet someone up on the fourth floor.

When the woman returned to the bar she found her friends gawking at her in disbelief.

"What are you guys looking at?" she asked.

"What were you doing back there?" one of her friends spoke up.

"I was talking to some guy. Why, what's up?"

"Are you joking around with us?" another doubting friend questioned.

"What do you mean? I was talking to some guy named Bill. He had to meet someone on the fourth floor, but he said he'd be back down. What's wrong with you guys?"

"There was no one there!" one of her friends stated, still unsure if she was being strung along as part of a prank.

"What are you talking about? Of course someone was there; I was just talking to him."

"There was no one there!" her friend repeated. "We thought you were just joking around, pretending to carry on a conversation."

The young lady looked around, and by the look on her friends' faces, she realized they were completely serious.

The infamous "Stephen's Corner" in the Orton Pool Hall, where the presence of young Bill is often encountered. The corner includes photos taken before and after the Orton Hotel fire.

"This is a one-story building," a friend interjected. "There is no fourth floor!"

The woman began to feel nauseous and quickly left the bar. It was only later that she learned about the story of the Orton and the death of William Stephens. She has never returned to the billiard hall.

The most terrifying incidents occurred in the pool hall between two and three in the morning, when the staff was closing down. Being below grade, there are no windows to allow in exterior light; therefore during a power failure temporary emergency battery powered lighting will come on to allow for a safe evacuation. On at least three occasions the emergency lighting failed to kick in after a loss of electricity and the pub was plunged into total absolute darkness.

When suddenly forced into absolute darkness it's natural to begin slowly feeling your way towards a known exit. It's just a little more difficult to do this while a waitress is frantically screaming and crying that you're not alone in the room!

The ensuing stampede was never pretty, as bumps, cuts and broken noses usually accompany running at breakneck speed through an inky black cluttered bar. But when the lights go out and a male voice suddenly whispers into one ear, and then quickly steps around and begins whispering into the other, running through a dark bar suddenly seems like a good alternative!

During a recent fundraiser a performer was in General Longstreet's, using the world's largest urinal (it's got to be seen to be believed), when he heard talking and footsteps coming down the hallway.

"I'm sorry," he shouted out. "The pub isn't open yet."

The footsteps stopped. The performer stopped and then stepped into the hallway, but there was no one there. It suddenly occurred to him that the front door was locked, and no one else was in the bar!

Today, the Orton Pool Room and Longstreet's Irish Pub are managed by the same owners of Fat Tony's Italian Pub, which is located on the first and only floor atop the cellar. But new management means nothing to wayward spirits. Even today, a burning odor, like that of paper, lingers about the building. The owners have searched in vain but cannot locate the source.

During a recent renovation of the poolroom a worker was walking by the dimly lit Stephen's Corner when he noticed a man sitting alone.

"Hey, how are you doing?" the worker said amiably as he passed by.

The seated man nodded his head in response, but as the workman was turning away he suddenly realized there wasn't supposed to be anyone else in the basement. He turned right back around, but the seated man was nowhere to be seen!

The Orton Hotel was a fine hotel. Tragically it went down in flames, taking with it the lives of two guests. If you visit the basement today, you may notice a young seafarer sitting alone at the back of the bar. You may even catch yourself exchanging a few words with this bright, friendly soul. But if the cellar suddenly plunges into absolute darkness, if an acrid smoke begins to fill your nostrils and you hear the whispering, run.

Run very fast!

THE COTTON EXCHANGE

I t was a time when rice was king! Though it doesn't have the same ring as "cotton," in the 1700s the grain of this cereal grass was Wilmington's number one agricultural export. Along the marshy, nutrient-rich tidal banks of the Cape Fear River, rice plantations thrived. It wasn't until after the Civil War that cotton became king in Wilmington.

While rice basked in all the glory, a low-lying area that abutted the old Horse Pond on North Front Street began to sow a different sort of seed. Abutting the Horse Pond was an enclosed pasture called a paddock. When it rained the low-lying pasture, or hollow, would flood. Over time the area was referred to as Paddock's Hollow, which eventually slurred into Paddy's Hollow.

In the 1700s squatters settled on this undesirable land, building lean-tos and rickety shacks. An eclectic mix of freed slaves and the destitute settled there. Soon other elements of the fringe society moved in: drunks, opium addicts, libertines and harlots. Paddy's

Hollow slowly developed into Wilmington's new den of iniquity, only on a much larger and more violent scale then its predecessor, Paradise Alley.

After three police officers were attacked by a gang of knife-wielding men, the police stopped patrolling Paddy's Hollow after sunset. Even after 1844, when the Front Street Methodist Church and adjoining graveyard were constructed at Front and Walnut Streets, and the Horse Pond was drained some years later, Paddy's Hollow continued to thrive. This even after complaints were lodged with local officials on how the raucous clatter of the drunken revelers was drowning out their Sunday sermons!

During the Civil War, brazen daylight robberies, assaults and murders were everyday risks in Wilmington, yet Paddy's Hollow was still considered too dangerous by the police to patrol. The young Confederate and Union soldiers who poured into Paddy's Hollow did so with no intention of helping to establish law or order.

In 1886 a terrible fire devastated Wilmington's north end, essentially destroying Paddy's Hollow. Along with hundreds of other structures that perished, the Front Street Methodist Church was lost. Though the church was rebuilt two blocks east, at Fourth and Mulberry (Mulberry is present-day Grace Street, and the church is named Grace Methodist United Church), it was decided not to relocate the graveyard to the new church site. Instead, the coffins were disinterred and reburied in Oakdale Cemetery. Or so it was reported.

The location of unmarked graves can never be known. Just a few blocks south, at St. James Episcopal Church, over 150 bodies have been discovered buried outside the boundary of the graveyard, the most recent discovered in 2003. So it isn't always easy to be sure you got all the graves. And even then, it's often far easier to remove the physical remains as opposed to the spiritual ones.

But who cares, because by then cotton was king!

By the late 1800s the north end of Wilmington was a serpentine maze of railroad lines, depots and enormous warehouses. The port at the foot of Red Cross Street bustled with commerce, as cargo-laden ships arrived daily. Along the bluff line of Front Street, between

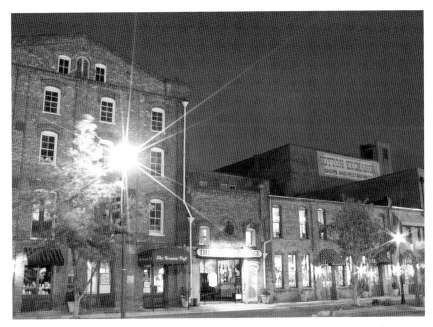

The Cotton Exchange is home to many ghosts, some the result of a more violent era and others the residual of a long removed graveyard.

Grace and Walnut Streets, a cluster of office and business buildings arose. The area was central headquarters to the thriving Atlantic Coast Line Railroad.

In 1955 the railroad announced it was leaving Wilmington. The old warehouses, train offices, switchback and depot fell into disuse. The old iron tracks were removed. One by one the magnificent structures perished. Progress, they cried!

In 1973 Wilmington was again a seedy and violent place. It better resembled the old Paddy's Hollow than the majestic city it is today. So when visionaries announced plans to remodel a cluster of buildings into what is today the beautiful Cotton Exchange, it was met with disbelief.

But today the Cotton Exchange thrives. It is a mix of quaint shops, boutiques and restaurants. A stroll through the magnificent complex will invigorate the soul. It's like stepping back in time. If you look carefully while perusing the extraordinary and unique shops you will

find many surprises, like two gigantic old Custom House lanterns on Front Street. You will also find an assortment of nineteenth-century tools of the cotton trade on display, as well as an old merchant wagon replete with its own bale of cotton. Look even closer and you will find trap doors, secret passages, giant earthquake bolts, the charred embers of a devastating fire and a one-hundred-year-old seed machine, replete with the original leather belts that once ran it. And if you pay extra careful attention, you may spot a ghost or two, or three!

THE GERMAN CAFÉ

Do you *Sprechen Sie Deustch Oder Geist*? Fortunately you don't need to speak either German or ghost to enjoy authentic Deutschland cuisine. Scrumptious entrees like rouladen und knodel, schnitzel and the famous Harvey's Reuben tempt the palate. But it is the homemade dessert that is to die for: Napoleons, tortes and fresh strudel. It's enough to make one want to stay there forever. Perhaps that explains their ghost.

The German Café is located in the old Granary Building. There are two dining rooms located in the back of the restaurant. It is between the two rooms that a spirit sometimes manifests and is encountered.

One such encounter took place late one evening, just after the restaurant closed for business. The owner, Harvey, was alone in the restaurant, preparing to lock up. He had just turned off the lights in the kitchen and was stepping into the dimly lit hallway when he glanced to his left and noticed a woman, a lady to be sure, standing at the top of the landing.

The stunning apparition was attired in Victorian clothing. She wore a beautifully flowing floor-length velvet-like gown. The gown was a deep shade of violet and trimmed in fanciful black lace. The lady offered no explanation as to her presence, neither in her proper stature nor in her expressionless gaze.

Harvey remained motionless, studying the radiant apparition. The specter began to lose clarity, appearing to drift in and out of

focus. As the seconds passed, Harvey became less convinced he was the observer as opposed to the observed. Then after a few indecisive moments the figure vanished.

Harvey took a long overdue breath, blinked his eyes, and then ran into the dining room, but it was too late. The lady had vanished.

It's been many years since that first encounter. Harvey's wife or another employee often remains behind as he locks up at night. But occasionally he finds himself alone. On those nights he always steals a quick glance up to the dining room, but she is not there, and he begins walking down the seemingly long hall with his back to the darkened interior.

It's then that he feels her, staring at him from the dining room stairs. The hair on the nape of his neck begins to rise, and he continues walking, willing himself not to turn around. He doesn't need to look, for he knows she is there.

It's only after he steps out the door and begins to walk away that she relinquishes her grasp on him.

THE AVON BOUTIQUE

It's unknown whether the womanly apparition seen in the German Café is related to the presence on the second floor of the building. But directly over the dining room where she is experienced is the Avon Boutique. Besides being stocked with a wide assortment of Avon products, the boutique offers its very own spirit.

Originally the boutique was located in a southern portion of the Cotton Exchange. Before moving to their new location, shelves and counters needed to be built. So as not to adversely affect the neighboring businesses, a carpenter was hired to do the work late at night after the shops had closed and the customers were gone.

On the first night the carpenter hauled all his equipment and tools upstairs. After laying out the materials and confirming all his measurements, he went to work. Since it was a late hour and no one was around to bother him, he fell into a good rhythm. Then, around

eleven that evening, while perched atop a ladder, nailing off a piece of trim, a woman screamed and a window slammed shut!

The shriek and explosive crash were so loud it sounded as if they came from inside the small shop. The carpenter quickly began looking around, including in the tiny storage room at the back of the shop, but there was no one there. Still, it was clear to him that it was time to leave.

The following night, under the guise of needing a helping hand, he asked his father-in-law to accompany him. However, as the work progressed, he confessed what had really happened. For the rest of the evening the father-in-law had a good chuckle at his son-in-law's expense. That is until around eleven that night, when a woman screamed and a window slammed shut!

A few weeks later, after moving into the store, the owner began to have her own experiences. Some mornings she would arrive to find the shop redecorated. Items that were stocked on one shelf the night before were now on a different shelf. Or all the items on a shelf were turned 180 degrees, with the labels facing the wrong way. Some mornings she would find all the lights of her miniature Thomas Kinkade Christmas Village she had on display burning brightly.

Even though the carpenter had his experiences, the shop's owner didn't feel the spirit was a threat. In fact, she had gone on to name the ghost Henrietta.

THE TOP TOAD

Above the German Café and across the hall from the Avon Boutique is the Top Toad. The Top Toad sells embroidered and silk-screen Wilmington and Cape Fear themed t-shirts, hats, sweatshirts and the like. They also carry interesting and unusual items both locals and tourists love, and have been in the same location since 1992. Since the day they opened the store they have also carried several spirits.

Sometimes they can be heard. When it's quiet and there are no customers in the store, the hangers on a display rack will begin to chatter as though brushed by an invisible hand. Sometimes you hear footsteps slowly walking around the store. Other times you can hear them speak. The voices are distant and the words are muffled, so it's impossible to understand exactly what they are saying.

Sometimes they are seen. After the rattling of a display a clerk may look up to catch a shadowy figure passing by. These images have also been caught by one of the four security cameras in the store. It's difficult to see around the corner of the L-shaped store, so when a sound is heard coming from a blind area of the shop the clerk's first instinct is to look up at the security screen. The murky, shadowy silhouette of a figure has been captured more than once.

But not everyone is a believer. One night a clerk's boyfriend stopped by and began making fun of the supposed ghosts. The next morning all of the window displays were found torn apart and strewn about the store!

The Top Toad carries those popular yellow diamond-shaped yield signs with fanciful animals, insects and clever sayings imprinted on them. One of the signs depicted a butterfly. For display purposes the signs dangled from nails along an old exposed wooden ceiling beam that runs the length of the store. Every morning the butterfly sign would be found lying on the floor. There was nothing to indicate why all the other signs remained attached to the beam and the butterfly sign was not. However, tired of picking the sign up off the floor and having to get the stepladder out to put it back up, the owner bent the nail holding the sign up into the ceiling. This way there was no way the sign could be removed.

The next morning the butterfly sign was on the floor. The nail that held it up there was still bent up into the ceiling! That afternoon the entire display was moved in order to avoid antagonizing the spirits. The butterfly sign has since been set free.

PADDY'S HOLLOW PUB & RESTAURANT

Paddy's Hollow Pub & Restaurant's only similarity to the original Paddy's Hollow is in name. The pub offers up some tasty American fare, from soup and salads to steaks and seafood. A longtime favorite of the pub is their flatbread menu. The bar is stocked with an array of ales and liquors and the atmosphere is soothing and quaint.

Paddy's Hollow is the closest you can get to the old church graveyard. Not only is it located near the northeast corner of the Cotton Exchange, but the ceiling of the pub is six feet under ground. Perhaps that is why the pub is frequently visited by a man in black.

During a recent renovation of the pub the bar was moved from the south wall to the north wall of the main room. On the afternoon they were drilling new beer line holes through the solid brick foundation, the manager of Paddy's glanced up from the work in progress and into the adjoining game room. Leaning against the open door of the kitchen's rear entrance stood a tall, gaunt man. His long wavy hair was jet black and he had on an equally black frock coat. The manager did a double take, not believing what he was seeing. But before he could utter a word the man in black turned, slamming the kitchen door closed in his haste.

The manager quickly ran around the bar and through the kitchen's main door, expecting to cut off this intruder. He burst into the kitchen shouting, "Stop!" A plate crashed to the floor as a waitress screamed in surprise. There was no man in black in the kitchen! As the chef so aptly pointed out, there were boxes stacked in front of the rear kitchen door, making it impossible to open!

THE SCOOP

Upstairs from Paddy's Hollow Pub & Restaurant is The Scoop. As the name implies, it is an ice cream shop. It is located in the beautiful courtyard, the most photographed portion of the Cotton Exchange. Besides offering a wide array of flavors and serving up generous

portions of ice cream, it is also home to a playful young lady who has a fondness for pranks.

During the day she will often run her fingers through the wind chimes inside the front door. She also enjoys playing with the microwave, blender, mixer and radio, turning them on and off as buttons are randomly pressed in and out. She has, over the years, swept piles of napkins and papers off the shelves and on several occasions has pushed stacks of dishes off the counter. Her image has been seen reflected in the glass ice cream case as well as on the store's clock face, which hangs a considerable distance off the ground.

Late one afternoon the owner of The Scoop was in the store alone. She was working at the counter, preparing an order for pick-up, when suddenly she felt her bunched hair lift off her neck. She swirled around, but as was easy to see, she was still the only one in the shop.

She turned back around and began working on the order. A few seconds later the tag on the inside of her shirt was pulled out over her collar. She swatted her hand behind her head, twirling in anger, but again, there was no one there. Perplexed, she tucked the tag back into her shirt and went back to work. A few minutes later the tag was pulled back out over her collar.

"Look, I don't have time for this right now!" she shouted. She was left alone the rest of the afternoon.

Like the ghost of the Top Toad, the girl can be heard speaking. She has a soft, girlish southern drawl and speaks with an innocent tone. She is usually heard speaking in the form of a question, though her words aren't always clear. Sometimes it's just a brief uttering, barely audible above the general din of the refrigerator's compressor. At these times it's easy to believe you're just hearing things. But other times it's much more clear and concise. The questions are illogical and nonsensical, perhaps only of matters she can understand. One employee who heard her voice quickly asked, "Why are you here? Why don't you move on?"

But the girl doesn't answer. Maybe she enjoys her playful ways too much to want to move on, or perhaps she is just too frightened of what lies ahead. Maybe she doesn't understand the force that holds

her and the other spirits of the Cotton Exchange in place. Whatever the reason, the spirits are there, and after so many years it may simply be that it feels too much like home to want to leave.

THE LEGEND OF COOTER

Before I built a wall I'd ask to know
What I was walling in or walling out,
And to whom I was like to give offense.
 —Robert Frost

A slave's life went unrecorded. Prohibited from learning to read or write, what little is known about individual slaves was passed down as oral history. Much like Homer's *Odyssey* their story survived from one generation to the next by word of mouth. And as is apt to happen some of the time, details evolve and fact and myth blend to the point where the story becomes folklore. And thusly the legend of Cooter exists.

There are secrets buried beneath the streets of Wilmington. Secrets, some argue, that are too painful to unearth. One of these secrets was discovered in the mid-1800s when a riverfront warehouse was being constructed on the southern end of the city. While preparing the foundation, workers uncovered a brick

tunnel. It's said the tunnel, an intricate maze of caverns, ran inland over a thousand feet before culminating in a thick expanse of woods. The tunnel is one of dozens believed to exist beneath Wilmington. But what was its purpose?

The tunnels were originally built in the early 1700s and were used to create drainage and to divert creeks underground. However, there are still many stories of pirates, smugglers and a criminal element that used the caverns as hideouts and for smuggling purposes. A particular brand of entrepreneur reportedly would lure the curious into some of these gloomy tunnels before robbing and murdering them. The victims' lifeless bodies were then dragged to the other end of the tunnel and dumped into the swamps that once surrounded Wilmington.

Over time the tunnels fell into disuse and by the antebellum period were mostly forgotten. As the city flourished some sections of the old tunnel were built over, while other sections, particularly where they met a basement foundation, were walled over, sealing off the underground chamber. Lula's Pub has one such wall, and it's where the legend of Cooter prevails.

Cooter was a habitual runaway slave. Though his actual name is unknown, his nickname probably derives from a large species of turtle known as "cooter," which are common to the ponds and swamps of the Cape Fear. Since slaves were allotted a limited amount of meat by their masters they often sought out other sources of protein. The cooter would have been an easy catch for a hungry slave.

It was probably while turtle hunting that Cooter discovered one of Wilmington's long-forgotten brick hollows. For when you're repressed, when chains and shackles bind you, you tend to notice little things like tunnels and hiding places. After separating himself from his owner, Cooter slipped into the abandoned tunnel and hid out, praying for a sympathetic abolitionist ship's captain to come his way. But a runaway slave in Wilmington was typically on his own, and Cooter's ship never arrived.

Upon Cooter's disappearance, a search party was formed. Soon hound dogs picked up his scent and the entrance to the tunnel was

discovered. As the barking and yelping of the dogs reverberated throughout the tunnel and the penetrating torchlight cast its eager glow, Cooter slipped deeper and deeper into the cavernous maze until he backed his way into a dead end.

When the searchers fell upon Cooter, they wrestled him to the ground and beat him mercilessly. But Cooter had been beaten before. It was all part of the game.

To Cooter's surprise, his captors began to tie off each of his ankles with coarse rope. His legs were pulled apart, sending waves of pain shooting up his groin. Cooter began to shiver against the cold dampness of the earthen floor. This was something he had never experienced before. His eyes became wide with fear as the crackling torchlight captured the terrible gleam of a freshly sharpened ax. And then it was over! With two swift blows Cooter's feet were chopped off just above the ankles.

"Now yer free, Cooter," his master sneered. "Go ahead, run away!"

And then, picking up Cooter's severed feet for later display, the search party turned and walked away. As he lay writhing in pain the last faint lick of torchlight faded to black.

The brutality of slavery is an ugly truth. Amputation was but a small part of the system of terror designed to deter runaways and to control slave uprisings. Amputation was rarely used, since a slave was an expensive piece of chattel, and cutting off his feet rendered him useless. It was usually reserved for the chronic runaway who couldn't be broken. When it was employed, it was often done in the presence of other slaves, in order to send a clear and concise message: seek your freedom, and you will pay a hefty price.

So Cooter, his feet freshly severed, was abandoned deep in the sinuous black cavern. While it's difficult to imagine the raw agony of the sudden violent loss of both feet, it's next to impossible to fathom the blinding surge of explosive pain Cooter endured as he tried to walk along the cold and uneven pressed earthen floor. Step by painful step he inched his way toward freedom, his gushing wounds clumping in the bloodied mud as agonizing jolts of pain

shot up each calf. All to no avail! For long before Cooter reached the entrance to the cave, delirious from blood loss and the unbearable pain, he collapsed and died.

Freedom can come on many levels, and for Cooter, death should have freed him from the earthly shackles that once bound him. Instead his soul became trapped, forever enslaved to the dark, narrow memories of these tunnels. He was denied that one glimpse of sunlight, that one breath of fresh air existing at the far end of the tunnel. Or perhaps, as many prefer to believe, his soul remained behind inside these tunnels where, even for just a brief moment, he was indeed free to come and go. Perhaps he chose, of his own free will, to remain there, to try and savor that ephemeral taste of freedom he was able only briefly to experience.

Lula's is a small bar. It is tucked away in the basement of the old Stemmerman building. Finding it can sometimes be a chore, and if you're claustrophobic you may want to reconsider popping in for a pint or two. For the entrance to the pub requires guests to pass through a dark, narrow tunnel!

On the other end of the tunnel you will discover a unique and very intimate bar. It's not one of those franchised, "It's The Weekend" dime a dozen bars that pollute main thoroughfares all across America. This is the real deal. But the first thing you need to do when you step into Lula's is to order a drink. Then, cozy up to the bar and be patient. Because you just may experience something special. For as the owners of Lula's will tell you, they've got their own certified ghost.

How else does one explain the strange occurrences that take place inside the bar? For example, how can a small gathering of regulars continuously mistake an additional presence standing at the back of the bar? And how can a figure seen in the back of the bar suddenly vanish without ever having walked out the front door? With one entrance and one exit, you can't go far. Or can you? Perhaps this elusive apparition has another way out. You see, directly behind the southeastern wall is a bricked over hollow that leads to the tunnel that is home to Cooter.

The long dark tunnel leading into Lula's Pub. This is just a hint of the narrow confines that hold the tortured soul of Cooter, a runaway slave.

But don't expect to take a peek in there. The owners believe it is best to leave this area well enough alone. They have agreed that they will never remove the brick from this section of wall, for whatever is behind here is not theirs. It is not ours. It belongs to another space and time, to an existence we can only sometimes catch a glimpse of.

Many patrons have experienced strange apparitions captured in the mirror behind the bar. While sitting at the bar they catch a brief glare of a shabbily dressed figure passing behind them. Only when they turn there's no one there. Is the mirror capturing the reflection of the elusive Cooter? Or is the mirror, as Kurt Vonnegut famously wrote, a leak in the universe, affording us a peak at another dimension?

Sometimes a Cooter encounter is an ethereal one. It's more of a feeling than anything else. It's the same feeling that may be experienced when traveling to an old foreign city. It's a lightness of being similar to déjà vu, where you become dizzy with the belief you've been there before. You can feel the presence of Cooter, but there's nothing to be seen.

Other times his presence is forceful. Scott Brooks stopped by Lula's one night while leading a group on the Haunted Pub Crawl. A male guest excused himself from the tour and stepped into the restroom. However, after finding the bathroom doors don't have locks he summoned his wife to stand in front of the door and make sure no one opened it. While standing with his back to the door he said aloud, "Are you in here, Cooter?" After he spoke these words he heard the door behind him begin to creak open. He turned, seeing the open door, and then watched as it slammed shut!

When he came out of the restroom his wife was standing in front of the door, talking to the same two people she was talking to when he went into the bathroom.

"That wasn't funny!" he reprimanded her.

"What wasn't funny?" she asked, more than a little perplexed.

"It wasn't funny opening the door and slamming it like that!" he said.

But as the couple she was speaking to attested, no one got near the door and it never opened or closed!

Lewis Musser was in Lula's with a group he was guiding on the Crawl when a woman who was leaning against the southeastern wall suddenly began screaming for help. Several patrons raced to her and pulled her away from the wall. Weeping uncontrollably she told her friends that someone grabbed her hair from behind and then pulled her back against the stone foundation. Of course there was no one behind her!

Another series of strange occurrences have sent patrons running. One night when Mike Hartle was leading a Crawl, the jukebox began to whir. The woman sitting next to the jukebox turned and looked at the machine with a puzzled look. No one had been near it the whole time she was sitting there.

"It's not you," Mike laughed. "It's the jukebox. It's an electro-magnetic occurrence and when it stops a dead artist will begin playing. But it will only play for a few seconds before going back off."

The woman smirked, casting him a disbelieving look. The jukebox stopped whirring and then The Doors began to play! A few seconds later the jukebox stopped and went silent.

"I told you," Mike laughed, as the woman got up from her chair and traded places with her husband, making him sit next to the jukebox.

Mike went on with the story when a few minutes later the jukebox again began to whir.

"It's going to be a dead artist!" Mike chimed.

When the jukebox stopped, Jimi Hendrix began playing. The husband jumped up from his chair and ran out of the bar. He was so frightened he refused to come back inside!

Then there's the whisper. One night John Henry Scott was conducting a Pub Crawl. A party of four was sitting at one of the far tables by the restroom when John began describing patrons sensing a presence standing in the corner of the bar. One of the women sitting in the back suddenly jumped up, knocking over the table and drinks, and ran shrieking towards the door. As she ran past John she screamed, "I hate you!" Her friends followed her out of the bar.

When the rest of the group left Lula's they found the woman and her friends waiting for them out front. The clearly rattled woman

apologized to John. She said when John was talking about sensing a presence she heard someone whisper something from behind her left ear. As she turned she saw there was nothing but wall behind her. She thought John had somehow done this trick in order to frighten her!

Lula's is a well-hidden secret that only the most persistent bar rat will find. And if you visit there you will leave, at the least, having experienced a genuinely unique pub. But if you seek a greater experience, you may choose to spend a moment along the walls of the bar. You may seek out a feeling that has been captured by many. A feeling they experience when they close their eyes and lean back against the masonry foundation. It's the surreal sensation that they are about to be pulled through the brick and into the tunnel. A tunnel where the indomitable spirit of freedom resides!

Gallows Hill

Contrary to Hollywood's portrayal, a typical eighteenth-century gallows was a rudimentary device. It consisted of two upright posts joined by a horizontal timber from which a short, coarse rope dangled. The noosed victim stood upon a wooden cart situated beneath the gallows, and as the wagon was slowly pulled away he reluctantly stumbled off.

After a short drop, strangulation began. As the shrinking noose crushed the airway, the bladder and bowels evacuated. The carotid arteries and jugular veins were squeezed and as the condemned struggled mercilessly, his face became engorged with blood, turning a ghastly shade of purple. The eyes would bulge and the tongue would swell and begin to protrude from the mouth. The lack of oxygen starved the muscles and they began to cramp. The spasmodic jerks of the struggling victim caused the rope to blister and tear the flesh of the neck. After eight to ten minutes the heart seized, leading to a much-welcomed death.

An execution was a social affair, and the morbidly curious demanded a good view. To accommodate as large a crowd as possible, wide, open expanses were often sought. In Wilmington, the logical place was along Market Street, at the top of a high sandy bluff east of present-day Fifth Street. This area is known as Gallows Hill.

In most violent seaside cities, among the damned were unknown seafarers from other ports of call. With no one to claim the bodies or to pay for burial expenses, shallow trenches were dug and the stiffening bodies were rolled in. Many bones have been unearthed in the Gallows Hill area of town.

As the population swelled, the city's limits expanded and the hanging device was moved elsewhere. By 1860, against the advice of his friends, Dr. William Price had built his family home on Gallows Hill.

Just after moving in, the family began hearing footsteps ascending their beautiful new staircase while no one was there. Other times they heard the sound of someone pacing around on the upper floors, or scratching noises coming from inside the walls.

Dr. Price was very much against the use of tobacco, yet occasionally the unmistakable odor of a corncob pipe lingered about the home. Other times it was the smell of candied yams or banana bread. Were these the items of last request of any of the condemned?

Before radio, televisions and computers, families once gathered in parlors to talk or read aloud together. The Price's parlor had more chairs than family members, so when they gathered there were always several vacant seats. Occasionally one or two of the empty chairs would begin rocking back and forth. These spirits visited so frequently that the family eventually named them George and Robert.

Early one morning the family discovered a four-foot long snake slithering across a bedroom floor. A few days later another was found curled up in a slipper, and still another in the bottom of Mrs. Price's knitting bag. Soon the serpents were everywhere. The home

had become so infested that the plaster on some of the walls and ceiling had to be removed in order to get to the nests where the snakes were breeding!

One summer a niece came to visit. Family accounts differ as to what exactly transpired between the girl and one of the ghosts; however, one descendant of the Prices, who shared their recollection during a Ghost Walk tour in 2000, had the most unsettling description of events. It all began one scorching July day.

Every afternoon the family would take a carriage ride along the riverfront, but one day the niece chose to stay behind. She sat in her bedroom in front of a beautifully ornate mirror and began brushing her long auburn hair. Even with the windows open, the room was stiflingly hot. So when the temperature quickly began to plummet, she felt it. But she was too innocent to wonder why the room was cooling; it just felt good. She continued to brush her hair, until a few minutes later when the mirror began to fog over.

Without knowing any better, she calmly wiped away the condensation and went back to her brushing. Again the mirror began frosting over. As she reached forward to swipe the glass a second time, she felt fingers running across her scalp.

Thinking her cousins had returned early from their carriage ride, she swiveled around, giggling in delight. There was no one there! Puzzled, she began to look around the room, calling out her cousins' names. Again, something began rummaging through her hair.

Screaming, she jumped up and began shaking her head frantically, trying to throw free the snakes she believed were nestled there. After a few frantic moments she realized there was nothing in her hair.

Panting and weeping uncontrollably, she collapsed back into the chair, and that's when she noticed the mirror. Through the fractured layer of frost, she saw the gauzy reflection of a man running his fingers through her hair!

She ran out of the room, down the stairs and out the front door. When the family returned they found the feeble, distraught girl cowering behind the knee wall that runs across the front of the home. The rest of her visit she slept in Dr. and Mrs. Price's room.

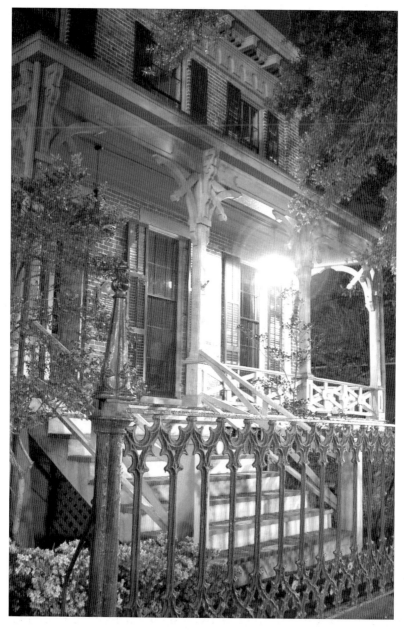

The Price House was built atop the hallowed ground still known as Gallows Hill. On the west side of the home is the parking lot known as the "burial ground."

In 1967 the Chamber of Commerce purchased the home and occupied it for over twenty years. They too had unusual experiences, and employees often complained about having to work there. When the Chamber relocated, a prominent local architect purchased the home, and it is now the day offices for BMS Architects.

They continue to have almost daily occurrences there.

In 1996, just weeks after Hurricane Bertha ripped through Wilmington, Hurricane Fran struck. The damage was extensive. Carolina Beach, on the southern tip of New Hanover County, was sealed off to residents for over a week. The evacuees had no idea if they even had a home to return to. With nowhere else to go, area hotels quickly filled up.

An architect with BMS who was displaced from his home in Carolina Beach requested and received permission to sleep in the Price House until the beach reopened. His first night there, he set up an air mattress in a second floor office that was once part of Dr. and Mrs. Price's old bedroom. The exhaustion that usually accompanies a hurricane set in and he fell fast asleep.

A few hours later he was startled awake by the sound of the first floor furniture being dragged from room to room. He jumped from bed, grabbed his car keys and, knowing he wanted to be no part of these ghostly shenanigans, he raced down the rear staircase and bolted out the back door. He slept in the Wal-Mart parking lot.

Early the next morning he returned to the home. When he arrived he found the manager of BMS there with fresh coffee and bagels. He explained to her what had happened, but a cursory glance was all he needed to see the first floor furniture was in its proper place. Yet the most embarrassing aspect of his ordeal was not the fact he left in such a panic he didn't even close the back door, but that he left in such haste he failed to grab a change of clothes, and was thus still in his pajamas!

The Price House is the most actively haunted home in Wilmington. Countless others have tried to spend the night in the home, only to be driven away. The unusual odors, frosting of glass, sounds of pacing footsteps, voices, grunts and groans, and the undeniable

feeling that one is never alone while in the house still persist. But the staff at BMS is quick to point out that most of these occurrences are non-threatening. The damage is typically done when people panic and try to run through walls or plate glass windows.

But the occurrences aren't confined to the cluttered interior of the home. Since 1999 thousands of guests of the Ghost Walk of Old Wilmington have experienced strange phenomena while standing outside the brick walls.

After business hours, when all the interior lights are extinguished and the alarm is set, the home is vacated. When the tour arrives it is typically to a completely darkened home. The group approaches the west side of the house, along the pitted dirt and gravel parking lot. The dusty lot is known as the "burial ground," because human remains were found in the vicinity by the Price family, and it's believed that other gallows victims are still buried there.

Sometimes guests experience something subtle, like the wafting odor of pipe tobacco or freshly baking bread. Other times it can be more robust, like the penetrating cold that grips several of the onlookers. It's sudden and bone-chilling, but lasts for only a few seconds and then is gone just as suddenly as it began. Many believe this is an actual encounter with one of these wayward spirits as they drift through the group.

On some nights, just getting to the burial ground is half the battle. It's difficult for some people to step off the sidewalk and onto the parking lot. In 2003 a mother was on the tour with her sleeping baby, who was being pushed in a stroller. The baby had not uttered a cry all night, but when the stroller left the sidewalk and entered the burial ground he began screaming. Not wanting to disrupt the tour, the mother backed the stroller and wailing baby onto the sidewalk. The crying ceased.

She tried to approach the group three more times, and each time the baby began screaming. When the tour moved on, and for the rest of the night, the baby didn't muster a peep!

In 2006 a woman was approaching the home from the burial ground and suddenly froze in terror.

"Help me!" she shouted. "I can't move!"

A man rushed to her side, grabbing her arm to pull her away. He quickly let go and jumped back, shouting, "She's ice cold!"

The trembling woman held out her arms and invited the others to touch her frozen forearms. After a few seconds she was able to lift her feet, which promptly carried her off to the safety of the sidewalk.

Others have become physically ill! This has happened to dozens of guests over the years, but the coincidence of two occasions was unique.

Denise Ward was leading a tour in May 2005. As her group traversed the dirt drive, a woman suddenly broke away, raced to the side of the house and began vomiting violently into the azalea bushes. A girlfriend quickly attended to the woman while Denise, who had seen this sort of thing at the burial ground before, asked if there was anything she could do to help.

"Please, start talking," the woman pleaded. "I don't want people watching me."

Denise promptly led her group to the backyard and did the story there. At the end of the tour the girlfriend explained to Denise that the sick woman had felt fine the entire night, until they stepped off of the sidewalk, when she immediately felt nauseous.

A few weeks later another woman broke free from the group, collapsed into the same azaleas and began vomiting. As the woman's husband attended to her, Denise began to tell the group how this was becoming a regular occurrence for her, when she noticed a woman with her hand raised.

"Do you have a question?" Denise asked.

"You don't remember me, do you?" the woman replied.

"You look familiar, but I'm sorry, I'm not sure how I know you."

The woman pointed in the direction of the vomiting woman and said, "That was me, three weeks ago! I was the one who got sick in those bushes. I came back tonight to hear the rest of this route!"

Then there are the frosting windows that overlook the burial ground. On some nights a window may show a hint of distortion, while on

other nights an entire pane or sash will freeze over. Frequently the event occurs slowly, over the course of the entire story, but sometimes it happens rapidly.

The phenomenon was first noticed on the tour in 1999. A group, having just witnessed a single pane freeze over, became so uncomfortable that they insisted upon leaving.

An occurrence in 2002 nearly sent an elderly couple to the hospital. Lewis Musser had just finished sharing the gallows story and was leading his group away from the home. Noticing an elderly couple had remained behind, he directed the rest of the group to head back towards the river for the final story and then returned to fetch the stray party.

As he approached he noticed the woman was trembling uncontrollably. Her husband pointed up at one of the second story windows. "There's something written across the ice," he said.

Lewis looked up and began reading off the letters. "I see an H and E," he said, moving a little to get some better light. "And it looks like an L and, oh, a second L."

"The second letter is not an L," the terrified woman cried, "It's a P! H-E-L-P!"

"HELP!" Lewis blurted in a brief moment of excitement that quickly turned to dread.

"Help from what?" The now trembling man asked, as he tried to console his frantic wife.

"I don't know!" Lewis stammered, as he ushered the couple away from the home. "But whatever help they need, I can't give it to them."

And with that the three took off running.

Of all the occurrences that have taken place outside or inside the home, one was responsible for more sleepless nights for the Price family than any other. It was a recurring incident, one that took place on the coldest nights of winter. The family would be asleep, bundled under layers of comforters, quilts and blankets. In the middle of the night, in the midst of their slumber, they would be startled awake by someone tugging on the coverings. Opening their eyes, they would discover a shadowy figure standing above them. As they looked on in

horror, their coverings were slowly dragged off their bodies, dumped on the floor at the foot of the bed, and then the figure would drift back and vanish.

It goes a long way to help understand why the Price House will never be a private residence again.

SAMUEL JOCELYN

Samuel Russell Jocelyn Jr. was the first of five children born in New Haven, Connecticut, in 1787. Shortly after Samuel's birth the family moved to Wilmington where Samuel's father, an astute businessman and attorney, recognized the opportunity available to him in a quickly growing port city. In 1794 Samuel Sr. was appointed the State attorney general for North Carolina, and his name appears on many surviving court records and town documents of the time. In the census of 1800 Samuel Sr. is listed as having a household with three children including a son (Samuel). Shortly after the census Samuel Sr. began operating a very successful salt-works company on Masonboro Sound.

Meanwhile, young Samuel, having been born into a wealthy and influential family, was afforded the best life had to offer. Indeed Samuel led a cerebral existence with tutors nourishing his growing intellect. When not being tutored, his time was spent in deep contemplation or discussing matters of current relevance with some of his many friends.

Samuel's closest and dearest companion was Alexander "Sandy" Hostler. The two friends shared many common interests, including gambling on cards and horses as well as "making the rounds" to the numerous social functions popular in their day. They also shared an interest in all things intellectual, including the supernatural. It was their interest in metaphysics that would culminate in a dangerous and dark undertaking.

One gray, rainy winter's evening, just a few years after the turn of the century, Samuel, Sandy and several friends huddled before the blackened hearthstones of a billowing fire. Over the incessant din of the pounding rain and grumbling thunder the friends found themselves immersed in one of their many philosophical debates. The topic was the future of man's existence and whether, after the spirit left the body, it had the power to return to earth and make its presence known. As the undulating glow of firelight cast cryptic shadows across the room, the discussion grew more and more heated. The soft cackle of the fire, whistling, hissing and popping, gave way to sudden, explosive outbursts of emotion. Samuel and Sandy argued in favor of the concept of a wandering soul while their friends argued just as fervently against such an idea. As the debate raged, damp logs were thrown atop the waning fire, which sparked, spat and purred. As the fire again raged to life, a gauzy smoke enveloped the room and the arguments for and against this proposition flew back and forth, much like their animated shadows, which leapt from wall to wall. Then, as the debate reached its crescendo, in front of all present, Sandy and Samuel made a pact: whoever of the two should die first would return from the grave and make his presence known to the survivor. Everyone fell silent as the gravity of the pact sedated the argument. The fire quietly offered its warm glow as the persistent rain stabbed at the blackened windowpanes. And then, as the others looked on in muted apprehension, Samuel and Sandy further agreed that upon returning from the netherworld they would provide some sort of irrefutable proof as to their momentary escape from the afterlife.

As the years passed, the memory and import of their pact faded. Samuel, like his father, expressed a keen interest in the study of law. He pursued his studies diligently and in 1807 his name first appears in court records involving a proceeding on the transfer of real property. Samuel also began courting a young lady by the name of Mary Ann Sampson, the daughter of a prominent counselor from Sampson County. On July 4, 1809, the two wed and settled in Wilmington where young Samuel planned to practice law.

The Jocelyn, Hostler and Sampson families were equally wealthy. Each family owned prime hunting land in the northwestern portion of New Hanover County (present-day Pender County). These elite families of Wilmington would often holiday at their hunting lodges. It was while on one of these holidays, on the evening of March 16, 1810, that Samuel and Mary Ann had an apparent altercation. The cause of the argument is unclear, though it's speculated it was a simple jealous spat. During the argument Samuel flew into a rage, and in a heightened state of dementia he stormed from the house clad only in his thin evening coat. Samuel's father was immediately summoned, but before he could stop his son, young Samuel mounted his horse and charged off on a gallop. Samuel's father gave chase, but Samuel was a skilled rider. As the dwindling rays of the setting sun faded, Samuel disappeared into the thick, murky woods of the swamp.

Recognizing the frail state of his son's mind and the lethality of the cold fetid swamp, Samuel's father immediately summoned a search party. Among those present were Sandy Hostler and Lieutenant Joseph Gardner Swift, a close friend of the Jocelyns. After two days of searching Samuel's body was found in four inches of chilled swamp water. He had suffered a fatal fall. His body was gently lifted free from the frigid water and placed on the back of a wagon. His lifeless body was then brought back to Wilmington, placed in a wooden casket and immediately buried in St. James churchyard.

Mary Ann Jocelyn was devastated at the loss of her newlywed husband. Samuel's mother and father were also completely distraught over the sudden loss of their aspiring son. But perhaps no one felt as much loss and pain as Sandy, who was inconsolable over the demise

of his lifelong friend. Sandy had not slept a wink since he was first summoned by Samuel's father to form a search party. After Samuel's burial Sandy retreated to his room where he continued to weep late into the evening. He knew he was on the brink of physical and mental collapse, yet he remained conscious, hunched over on the edge of his bed, in a near catatonic state. Late into the evening as he emerged from his gloomy repose, the oscillating flicker of candlelight captured a startling site. There before Sandy stood his friend.

Sandy sat on the edge of his bed hyperventilating, staring up into the weary gaze of Samuel's eyes. In a barely audible voice Samuel whispered, "Alexander…"

Sandy was frozen with fear. The bile rose in his throat and he was unable to speak.

"Alexander," Samuel again whispered. "Come and dig up my body."

But before Sandy could mutter a response he fainted in fright.

When Sandy regained consciousness he found his room empty. A barrage of thoughts assailed his tortured mind. He tried desperately to make sense of Samuel's appearance. He wondered whether it was really Samuel who stood before him. Could his spirit have really just spoken to him? Or perhaps it was a hallucination brought upon by his frail state. His thoughts had been entirely on Samuel for days. In such a state his exhausted mind must have conjured the image of Samuel. And thus, having convinced himself Samuel never stood before him, Sandy felt it best to mention the affair to no one.

Then late the next evening, the image of Samuel appeared for a second time. Samuel reiterated the same strange request for Sandy to come dig up his body before his gossamer figure dissolved into the murky shadows of the room. Again Sandy convinced himself it was all just an illusion brought upon by his own mind. Again, he told no one of what had occurred.

And then, as dawn crept into Sandy's room sleep finally came. It was well after midnight when he finally awoke. The disorientation of waking in a darkened room briefly confused him, but after several minutes he realized he had slept through the day. Refreshed, he sat on

the edge of his bed and lit the oil lamp beside his bed. As light crept across the room Samuel stepped forward. Sandy began to tremble in fear as his friend again made his request. Moments later Samuel was gone. Sandy realized his friend's appearance was more than just an illusion. He knew he needed to speak with someone about these encounters, and with Samuel gone, Sandy chose his next closest friend, Louis Toomer, to confide in.

Louis was a good friend to both Sandy and the late Samuel. He was pragmatic and sensible, but not rigid. Though he considered himself a realist, Louis was not above the possibility of the supernatural. He was just the sort of friend to help Sandy sort out the enigma of Samuel's appearances.

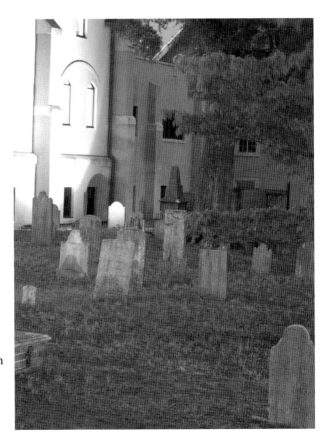

St. James Churchyard, where there are more eighteenth-century headstones than in any other collection in North Carolina. Final resting place of Samuel Jocelyn.

The next morning Sandy arrived at Louis's home. Sandy vividly described the three encounters. Louis soberly mulled over each word and detail, then after an hour of intense scrutiny and thoughtful pondering, Louis stood up and began pacing the parlor floor.

"I believe Samuel's appearance has something to do with your pact," he stated, reflectively.

Sandy looked at him questioningly. "My pact?"

Louis stopped pacing. "You mean you don't remember?" he asked in disbelief.

"Remember what?"

"It was years ago," Sandy continued. "We were talking about the afterlife and the possibility of coming back from death. You and Samuel were inclined to believe this was indeed possible. It was on that night the two of you made a pact: Whoever should die first, they would come back from death and make their presence known to the survivor."

Sandy began to tremble. "I remember now!"

"I think it's safe to say Samuel remembers as well."

Sandy's breath came fast. "But why does he ask me to open his coffin?"

"Perhaps," Louis answered, barely able to hide his excitement, "it pertains to the second part of the pact, that if at all possible the spirit would provide some sort of irrefutable proof of the momentary escape from the afterlife. Samuel has left that proof for you, that gift, concealed somewhere in his coffin."

It felt to Sandy as though all the air had left the room. He sat stunned by such a prospect. The proof of the afterlife would be the find of the century.

For the remainder of the morning Sandy and Louis discussed the possibility of such a treasure. Then, as the sun reached its zenith, the two came to an agreement. Without another soul's knowledge, they were going to exhume their friend's body.

After midnight that evening, as a misty layer of spring fog blanketed Wilmington and the dim glow of a crescent moon struggled to leak through the smothering haze, Sandy and Louis met in the woods beside the cemetery, beneath a towering live

oak. Each carried a shovel and a dark lantern with closed slats in order to prevent light from escaping. With no homes within a block of the churchyard, under the cover of darkness and the lingering fog, confident their intentions were indeed secret, they entered the graveyard.

Sandy and Louis carefully negotiated the scattered gravestones until they came upon the fresh belly of soil atop Samuel's grave. The thick arthritic limbs of a massive live oak intercepted what little light the moon dispersed, blanketing Samuel's grave in obscure shadow. The two men stood rigid on either side of the mound. Without uttering a word they went to work.

The incessant swish of the spades plunging into the soft, loose soil quickly developed into a monotonous rhythm. Despite the cool, damp night the two men sweated profusely, only in part from exertion. The discomfort at what they were doing, or perhaps worse, of getting caught in such a morbid act, weighed heavily on both men. Inch by inch they plodded, slipping further and further into the depths of the grave. The hidden moon and the overlaying fog prevented any ambient light from penetrating the growing hollow. After an hour of tirelessly digging, the indelible sound of Sandy's shovel thumping against the top of the wooden casket resonated throughout the earthen pit. On their hands and knees they cleared the remaining soil from the top of the casket.

When the entire roof of the coffin was exposed, they began digging a small hollow beside it. The shallow tunnel was equal to Sandy's width and depth, and by backing into the narrow confine, he was able to kneel beside the casket.

With difficulty, Louis extricated himself from the pit. He passed a pry bar down to Sandy, and then he retrieved a dark lantern and partially opened one slat in order to allow a sliver of light to escape. He then lay down beside the grave and dangled the lantern over the edge, which allowed in just enough light to help Sandy discern the nails that secured the coffin's lid. One by one Sandy pried the nails free until none remained. Then, backing into the small cavity beside the coffin, he lifted the lid free. Louis closed the slat of the lantern

and placed it on the ground beside him. He then reached down into the pit and lifted the lid free and carefully leaned it against the knotty trunk of the live oak tree beside Samuel's grave. He then passed a dark lantern down to Sandy.

Aware that the sides of the pit would block the bright light of the lantern, Sandy opened the slats wide. The black void filled with blinding light. As Sandy's eyes slowly adjusted to the glimmering brilliance, his gaze slipped into Samuel's coffin.

A low, guttural moan escaped Sandy's lips. He began to sob uncontrollably.

"Why didn't I come to him on that first night?" he cried.

Louis was too shocked to answer. He merely shook his head in disbelief.

Samuel had been buried alive!

In tears, Sandy slumped against the damp earthen walls of the grave. A collage of pungent odors assailed him: rotting flesh, urine and feces merged with the dank, putrid soil of the grave. Numb from the reality of the situation, Sandy reached into the coffin and began to turn Samuel's body back over. Rigor mortis had already set in, stiffening Samuel's contorted body in a slightly hunched posture; the body wedged firmly between the sidewalls of the coffin. Sandy slipped his hands under Samuel's cold, bloated armpits. With incredible effort he pulled the body upward. The sound of Samuel's flesh tearing free from the wood flooring filled the grave. Sandy flipped the body onto its side and propped it against the upper edge of the casket, pausing to catch his breath.

"Do corpses bleed?" Sandy asked Louis, without looking up.

"What do you mean, bleed?"

"There's blood in the bottom of the coffin. Is it normal for the body to leak blood after death?"

"I don't know," Louis stammered uneasily.

After catching his breath Sandy again grasped the body under the arms and with a concerted heave he flipped Samuel upright. The body dropped back into the coffin with a dull thud. As if intentionally drawn, Sandy's gaze immediately fell upon Samuel's bulging eyes,

which glared back in icy terror. His death mask was one of pure agony, the mouth agape, frozen in a silent scream. His stiff, dry tongue protruded slightly across the lower teeth, and his hands were clasped tightly around his neck, as if in a stranglehold. And then in an image more terrifying than Samuel's death mask, Sandy noticed the fingers. All ten of Samuel's fingertips were shredded apart. Jagged fragments of milky white bone poked through bloodied chunks of torn, dangling flesh. In terror Sandy scampered out of the grave. Louis, in the meantime, held the other lantern to the inside lid of the coffin. The white satin lining had been torn to pieces. Deep bloody gouge marks etched the wood from where Samuel tried to claw his way out, and all ten of Samuel's bloodied fingernails pinned to the splintered wood where they had been torn free from his frantically clawing fingers.

Sandy and Louis sat with their backs to the immense live oak, each of them silently imagining the horror of Samuel's final moments.

"What do we do?" Sandy finally asked, trying to free his thoughts from the grave.

It was clear there was no good that could possibly come from letting anyone know of their gruesome discovery. The pain and sorrow it would cause Samuel's parents, knowing they buried their son alive, would undoubtedly kill them. And then there was Samuel's young wife to consider. Mary Ann and Samuel's life together had just begun, and the loss of her newlywed husband after a lover's spat was devastating enough. If she were told the truth of Samuel's death she might never recover. No, it was obvious to both Sandy and Louis they needed to re-bury Samuel and keep the secret of their discovery to themselves.

The act of being buried alive was not an uncommon occurrence before the invention of the stethoscope in 1920 and, later, embalming. It was stories like Samuel's that made the fear of being buried alive a very real one in the eighteenth and nineteenth centuries. The fear was so great for some that it became a practice in many places to be buried with a string tied to your finger. The string would run out of your coffin and be attached to a bell on your neighbor's gravestone, for your gravestone might not have been ready so soon. This way if

you were "accidentally" buried alive and you came to in your coffin, you could ring the bell and someone might hear it and come to your rescue. It was in this practice where the phrases "saved by the bell," "dead ringer" and the "graveyard shift," all had their origin (the graveyard shift alluding to those you would pay prior to your death, who would sit in the graveyard in shifts, around your plot, in case the bell began ringing).

Still, the fact that Samuel was mistaken for dead seems inconceivable. Part of the reason for this has to do with the way the story has always been told. In the spring of 1880 Colonel James G. Burr, a well-respected local historian, was the first to publicly speak of the matter of Samuel's fate. In his speech to the Historical and Scientific Society of Wilmington, Colonel Burr states Samuel was "thrown from his horse while riding in the woods and his body was found lying by the roadside." He goes on to say, "every effort was made to restore him to life, but in vain, and the following day his remains were borne to the grave and buried in the old Churchyard of St. James." Later accounts claim Samuel was riding only a few blocks from the graveyard itself. Some go so far as to claim his body was actually found beneath the tree that he was eventually buried under.

But none of this explains how Samuel could have been mistaken for dead. The argument has been that while riding alone Samuel's horse apparently threw him and he struck his head on the ground, thus leading to a comatose state. The problem with this argument though is that a coma may cause profound unconsciousness but it does not affect one's vital signs. Though his heart rate and breathing may have slowed considerably, they still would have been strong enough to detect. There had to be something else.

In 1804, six years before Samuel's death, Lieutenant Joseph Gardner Swift arrived in Wilmington under orders from the War Department. He was assigned chief engineer in the Army's Corp of Engineers, to plan and execute the rebuilding of Fort Johnston. Lieutenant Swift was a prominent figure in Wilmington. He considered among his friends the Jocelyn, Hostler and Toomer families. He would occasionally join

the men on hunting parties in the northern reaches of the county, including the Holly Tree Swamp.

In Lieutenant Swift's memoirs, which were published in 1890, ten years after Colonel Burr's speech, there is an entry dated March 18, 1810. Lieutenant Swift writes, "In the company with many men from Wilmington on a search for the son of our friend, Samuel R. Jocelyn... the body was found in Holly Shelter Swamp." He goes on to write that young Samuel entered the swamp in "a demented state" and his body was found "chilled to death lying in some 4 inches of water." He closes the entry by stating, "His name, Samuel, and recently married to a daughter of Counselor Sampson, of the county of that name."

It's clear that Samuel appeared to be dead the moment he was found, since the Lieutenant states "the body" was found. The fact that he was found, "chilled to death lying in some 4 inches of water," implies he was found lying face up, otherwise he would have written they found the body having "drowned" in 4 inches of water. This account alone goes a long way in helping to explain how Samuel was mistaken for dead.

If Samuel had fallen or was thrown from his horse and knocked unconscious, perhaps very much in a coma, the cold March swamp water would have slowed his vital signs considerably. His pulse could have feasibly slipped to two or three beats a minute and would have been so weak as to be nearly undetectable. His breathing would have also been extremely slow and shallow. Even today when someone dies from hypothermia, the body has to be warmed to at least ninety-one degrees before they can be legally pronounced dead. Between the primitive medical equipment available in 1810, the demented state that led Samuel into the swamp and the conditions in which they found the body, it's easy to see why everyone present assumed Samuel was already dead. A cursory exam would have failed to detect a pulse or even a breath.

Having been found, Samuel's body was lifted free from the frigid waters and placed on the back of a wagon, still wrapped in his thin, wet clothing and fully exposed to the frigid March temperatures. Since the Holly Tree Swamp is some miles from Wilmington, it took

several hours to return to town. Upon returning the body was then placed in a coffin, and, since it was thought Samuel had already been dead for several days (and more specifically, the body had been decomposing for two days), he was immediately buried. As his body thawed in the warm cavity of the earth, he awoke from his state of animated suspension.

Within a year of Samuel's death his mother died, perhaps from grief at the loss of her eldest child. Soon after, Samuel's father also followed his son to the grave. In 1818 Samuel's widow remarried and went on with her life. As the years passed Sandy Hostler and Louis Toomer struggled to keep their secret intact. Unable to contain the truth any longer, Sandy shared his experiences with a near relation of his. The relation turned out to be Colonel James Burr's mother. Louis eventually shared his secret with a close friend of his family. The friend turned out to be Catherine Kennedy, a prominent and well-respected Wilmingtonian. Ms. Kennedy eventually shared the story with Colonel Burr, giving him an account of Louis's words in writing.

Regardless of how the story is told to this day many older Wilmingtonians refuse to walk alongside the cemetery. They believe that if you walk by Samuel's grave at a quiet enough hour, when there are no cars whizzing up and down Market Street or heat pumps humming, you can sometimes hear Samuel's muffled cries emanating from the graveyard. Still other brave souls have sought out the grave of Samuel Jocelyn in response to a dare. This was before the graveyard was surrounded by fencing and patrolled by security lighting, guards and cameras. The dare was they would lie down atop Samuel's grave for one hour, by themselves, after midnight, with their ear to the ground. (Some argue this is impossible since the exact location of Samuel's grave is unknown, partially because there are so many missing or illegible gravestones in the graveyard and partially because of missing plot plans from the period of Samuel's burial.) Nonetheless, no one has ever come forward admitting they lasted that hour. Every single one who tried was up and racing out of there, vowing they would never return to

the graveyard again. They claim that as they lie there with their ear to the ground, from beneath the cold, dank soil, they could hear the unmistakable sound of scratching noises.

Despite all of the inconsistencies, one fact perseveres: Samuel Jocelyn was buried alive in 1810. At some point he awoke to an indescribable darkness. His first conscious breath would have drawn a stale, almost un-breathable air. Perhaps he then tried to raise his hands to his aching head, only to find he was trapped in some restricted space. Then, in an utter state of confusion, as the dullness of his long sleep quickly cleared, Samuel experienced an epiphany. At that moment he knew where he was. One can only imagine the horror of that moment. Yet, no matter how hard you try this evening, while lying in bed in your darkened room, you can never fully imagine that moment. Fighting with every ounce of strength available to him, Samuel tried desperately to claw his way out of his tomb. And then, as the oxygen quickly began to dwindle, with one last fit of strength, he rolled over in his coffin. As his lungs burned in fury, as each breath became more and more elusive, Samuel Jocelyn finally died. Death could never have been so welcome.

AN ENGLISH
GENTLEMAN LOST

In 1760, a young man by the name of Llewelyn Markwick arrived
from England, bearing letters of introduction from prominent
Londoners. On a finger he sported a large ring depicting two
intertwining snakes with their heads upright. Clasped in their jaws
was a giant diamond. He said it was a one of a kind ring, a replica
of his family's crest.

Markwick was also an avid rider and owner of a well-trained
horse. Immediately upon dismounting the animal, Markwick
would point it toward the stable, slap it twice on the neck and the
horse would trot off to its stall.

One night Markwick told the stablemen he was going on a
ride and would return later that evening. Sure enough the horse
was found back in its stall; however, the next morning it was
discovered that Markwick himself had never returned from his
ride. An intensive search was conducted, but he was never heard
from, alive, again.

In 1768 a terrible storm blew through Wilmington. The next
sunny morning after it passed, a gentleman was walking along the

sandy road near present day Third and Dock Streets when he noticed a large portion of road had been washed away. As he navigated his way around the large, eroded area, he noticed something shiny protruding from the muck.

He climbed into the hole and tried to lift the object, but it was affixed to the ground. As he began to dig, other passersby jumped in to lend a hand. And that's what they found! A bony hand with a ring attached to the finger. As they completed digging out the body, the riding clothes confirmed this was Llewellyn Markwick.

Though he had been shot from behind, the valuable ring and purse that remained on his body seemed to rule out robbery. So it was deduced his death was the result of mistaken identity.

Apparently he was shot while riding into town along the old Brunswick Ferry Road. When his assailants approached they quickly realized their mistake. As the horse trotted off to its stall, Markwick's body was dragged to a wooded area, conceivably next to the present-day St. Thomas Preservation Hall. Root mass would have prohibited a hastily hand-dug grave, so an area was prepared in the soft sand of the roadway.

Though the storm-eroded roadway and grave were eventually refilled, a portion remained susceptible to collapse. Though some argued the soil simply wasn't compact enough, it wasn't the large, washed-out area that was sinking. It was only the small portion that was once Markwick's grave. When the roads were eventually hard-coated the issue went away. However, that's when residents were introduced to a new problem that persists to this day.

A strangely dressed man has been seen stumbling about Third and Dock Streets, as though he's in need of help. As those familiar with this area of town know, this in itself is not unusual. However, many good Samaritans, including members of our local law enforcement, have stopped to lend this figure a hand, only to find that as they approach, he simply vanishes before their eyes!

One evening, a couple crashed their car into the giant Confederate War monument located in the intersection of Third and Dock Streets. The driver tried to explain to the police how a man in outdated

The alleyway beside St. Thomas Preservation Hall, where the apparition of Llewelyn Markwick is often seen astride his horse.

clothing stepped off the curb and into oncoming traffic. His vehicle passed right through the apparition, and the driver, who swerved reflexively, smashed into the statue!

Seeing as to how it was just after last call on Saturday night, the driver was promptly arrested.

However, others have seen Markwick's ghost still astride his steed. One evening a family was walking up Dock Street when they noticed a man on a horse outside the alleyway of St. Thomas Preservation Hall. The children begged for permission to pet the animal, but unsure who this strangely clad figure might be, the father approached first. Before he could utter a word, the whining beast reared up with legs flailing, then crashed to the ground and began charging down the alley. Twenty feet in, the horse and rider vanished before the family's eyes. Startled, they raced down the hill, back to their home,

terrified by what they had just encountered. The next morning a neighbor told them the story of Llewelyn Markwick.

If Llewelyn Markwick is seen riding a horse, it's probably not his well-trained steed, for that is what he's been looking for. And if ever finds that well-trained horse, perhaps he'll complete that long journey home and his spirit will be set free from these parts.

THE OLD RHINO

In 1756 a wealthy physician with the unwieldy name of Cosmos Farquharson (fark-a-horse-en) died. He owned the land that now encompasses the southwestern block of Market and Second Streets. He was a gentleman and a farmer, a true man of the soil, and so upon his death, as per his will, he was buried directly in the dirt, free from the confines of a coffin. His estate was then distributed equally to his children.

Unlike Dr. Cosmos Farquharson, many people who died in Colonial Wilmington willed their property to the Masons. The Wilmington Masons first formed here in 1754. Their first lodge, which is now part of the Children's Museum on Orange Street, was completed in 1804. As the order grew, so did the need for larger quarters. A new building was constructed atop the very soil Dr. Cosmos Farquharson so loved, and whose remains still lay hidden beneath.

The new St. John's Masonic Hall was completed in 1841. Built in the Gothic Revival, later renovations obliterated the original genre. Meetings and balls actually took place on the third floor, which

featured beautiful hand painted frescoes and an organ and choir box. Guests of the lodge included presidential hopeful Henry Clay in 1844, statesman and orator Daniel Webster in 1847 and America's eleventh president, James Polk, in 1849.

One of the state's first libraries opened on the second floor, while the first floor operated as a grocery. It was at this grocery in 1878 that a scandalous affair came to a tragic and violent end.

Mary Ratcliff was born on the eve of the Civil War. Though her father was the son of a wealthy plantation owner, her mother was a slave, and so Mary began her life as chattel. When the war ended and Mary and her mother were freed, Mary's mother sought work in town, where Mary would be raised. She grew to become an attractive woman with beautiful large brown eyes and a captivating smile. She attracted many suitors, including a secret admirer by the name of James Heaton, a prominent white man who was a North Carolina congressman.

James insisted they keep their relationship secret, fearing it would hurt his political career if it were known he loved a former slave. Mary didn't care either way for she was simply in love. In the end, though, James Heaton possessed two characteristics that would doom their secret relationship from the start. James Heaton was both a jealous man and a bad drunk. The combination proved fatal, for one evening while suffering from both afflictions, James slashed Mary's face with a knife. Mary fled and hid out at a friend's house.

Several nights later, on July 12, just after 11:00 p.m., Mary asked a friend for assistance in carrying several packages to her home. She was being very cautious, knowing James had been looking for her in order to apologize. While walking up Market Street, Mary and her friend met another couple standing outside of the grocery store. Mary was anxious to get home, but before she could break free from her friends, James appeared out of nowhere.

James was unbalanced and his breath reeked of whiskey. Mary tried to hide in the shadows of the dark alcove of the grocery, but James approached her, extended his hand and asked her where she had been

the last few days. Mary refused to take his hand. He offered his hand three more times and each offer was rejected by a resolute Mary. With each refusal James became more and more incensed.

"Don't be a fool, Mary!" her friend urged. "Take his hand."

"No!" she spat. "I'm done with him!"

With this response James became enraged. "Damn you, I'll make you have something to do with me!" he shouted wildly, withdrawing a pistol from inside his coat and firing a single shot at point blank range into Mary's chest.

"Oh, he has killed me!" she cried, falling back into the alcove.

James raised the pistol to Mary's head, oblivious to the terror in her eyes, and then fired a second, fatal shot. He then turned and fired a third shot in the direction of Mary's friend, who was now running down Market Street.

Quickly realizing his predicament James began running with the police in hot pursuit. He ran northeast up to Fourth and Princess Streets where the police closed in. Cornered, with nowhere to run, James placed the gun into the indent of his right temple and fired one last shot.

But the tragedy doesn't end there.

In the early 1990s downtown Wilmington was just awakening from a long, deep recession. The grocery and the lodge were long gone and the old St. John's Masonic Lodge building, like much of historic Wilmington, suffered from years of neglect. But in the early 1990s new life was breathed into the building with the opening of the Rhino Club. The Rhino Club was a private bar, which according to state law meant the establishment could serve hard liquor without serving food only if their guests were "members." It's a quaint, antiquated state law designed to make sure that even the most slovenly drunk has a place to call home.

But the staff of the bar quickly realized this was no ordinary building.

One evening a waitress was wiping down one of the tables. As her damp rag raced across the stale surface of the table the name "Mary" momentarily appeared in the smudgy glare. It was odd

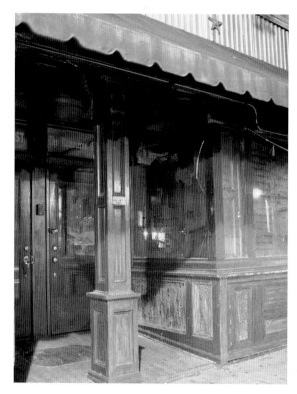

The alcove where Mary Ratcliff tried to hide from her deranged lover, James Heaton. It was here that he withdrew his pistol and shot her twice.

because it was the third time that week she had seen the name Mary appear somewhere in the bar.

Later that night she asked the bartender if he understood the significance of this. He then shared with her the fateful story of Mary Ratcliff and then pointed to the giant mirror over the center of the bar.

"If you look carefully on any given night you will see her name written across that mirror. It looks like smudge marks, but if you move around carefully, and if the light is just right, you'll see it as clear as day."

And there it was!

It was the last night she worked there. As she later explained, she had no interest working in a bar where a dead person was attempting to contact her.

A few years later a bartender was alone in the stockroom pulling fresh bottles for the evening rush. He was awkwardly bent over several boxes, searching for a specific bottle of liquor, when he heard a woman whisper something incomprehensible from just behind him. Grunting, he extricated himself from his awkward pose then turned to find the room empty. It was odd, because it very much sounded like this voice was right behind him. Still, he stepped out of the room and into the hallway, thinking the voice was perhaps coming from just outside the room, but again, there was no one there. Thinking he had somehow misheard a louder conversation coming from the main room, he headed back into the stock room to continue his search anew.

Again, while leaning awkwardly over several boxes, a whispering woman's voice uttered something completely incomprehensible from directly behind him.

"Is someone in here?" he called out without attempting to stand up.

And then he felt a hand reach under his shirt and touch his back.

As he fell forward over the boxes he kept shouting, "Who's there, who's there?"

But there was no one there. For this time the stockroom door was closed and he was clearly alone! He quickly got what he needed and got out of the room. He too quit working at the Rhino not long after this occurrence.

One night after closing, another male bartender was alone in the bar. Foolishly believing the ladies' room to be cleaner than the men's room, he stepped into one of the stalls and closed the door. While in the stall he heard the footsteps of someone walking into the restroom.

"Is anyone there?" he called out.

No one answered.

"Hello? Is anyone out there?" he called out again.

Then the stall door next to his opened and closed. He peeked under the stall divider, but clearly there were no feet.

"Who's there?" he screamed out in panic, bounding off the commode to the other stall where he nearly ripped the door off the hinges.

The stall was empty!

A few months later he and a waitress were shutting down the bar. The CD jukebox was blaring, when suddenly the speakers began to distort and crackle. From the strange incessant hissing and popping could be heard what sounded like an old scratched record playing some long ago faded song. And then a few seconds later the CD began playing again. This, he was convinced, was an effort by Mary to contact them in an electromagnetic means.

There are also patrons, mostly of the male persuasion, who claim to have seen Mary. She always appears in a black floor-length dress, standing alone in one of the dark recesses of the dimly lit bar. These bar rats, saturated with enough rum to drown a tiny village, with a hormonal explosion strong enough to ignite a small sun, approach what they describe as "prey." Only by the time they make their way across the room, this stunning vision is gone. Of course no one else in the club can recall having seen her in the club that night.

Are all of these occurrences attempts by Mary to make her presence known? If so, how do you explain some of the other occurrences? For example, how does one explain the wall of kegs?

A onetime manager of the Rhino would periodically open the mammoth refrigerator door to discover a wall of kegs stacked from floor to ceiling, blocking the entire entrance into the refrigerator. With incredible effort and with explosive results, the wall of kegs would be pushed over in order to get into the refrigerator. In other words, the only way the kegs could have been stacked in this manner was from the inside of the room.

Certainly this couldn't have been done by the dainty Mary Ratcliff. Could it be the spirit of James Heaton lingers here too? Can fate be so cruel to confine these wayward lovers to the same spiritual limbo?

Encounters with the second spirit in the Rhino Club are always described as "brutish," "brash" or "forceful," much the way Heaton was described when he was drunk, which was more often than not.

This male apparition has been described as a figure of medium height draped in a black long-coat and black pants. The cut of his clothes, including the vest and the top hat, all indicate rather outdated

attire. Those who have witnessed this apparition say there is a sickly feeling of dread whenever his image flashes by.

A female bartender witnessed this apparition on three separate occasions. Each time the bar was swollen with revelers, and the image appeared for just a moment before being lost in the ebb and flow of patrons. On two occasions she saw him leaning against the restroom wall. On the third occasion he was standing in the alcove that led to the old billiard room.

And like Mary's spirit, he has made his presence known in the restroom. Male patrons, standing before a urinal, have described a warm breath across their necks and the uncomfortable feeling of someone standing directly behind them. Only when they turn there is no one there.

In 2004 a Marine and his wife were on the Haunted Pub Crawl. Their guide, John Henry Scott, had just led the group into the pub where they dispersed, some heading for the bar and some heading for the bathrooms. When the group was ready John gathered them at the end of the bar and was getting ready to begin sharing the story of Mary and James.

"Tell him what happened," the Marine's wife began pressing her hulking husband.

"No, no, no." he stammered, shaking his head. "It was nothing."

"Did something happen?" John asked.

"No, it was nothing," he assured John, making it clear he didn't really want to discuss it.

So John began the story. When he got to the part about the men's room with the breath of warm air on the neck and the feeling of someone standing directly behind you, John could see the Marine's eyes grow as big as the moon. When John finished the Marine was actually trembling.

"That's exactly what just happened to me in the men's room!"

And so we have a clandestine romance, with two lovers whose tragic fate left them to remain side by side for eternity, stuck here in the place where their hideous demises are forever remembered. Mary Ratcliff, a beautiful woman who had the misfortune of being murdered by

her lover in the alcove out front. James Heaton, the cold-blooded murderer, who took his own life rather than face public scrutiny.

The experiences of these two spirits are distinct and distant from one another. Sadly, despite the passage of time and despite their condemnation to have to spend eternity together, they will always be apart, always separate, doomed never to unite and be one! It's the sad ending of a love story gone wrong. It is a tragic ending to a story that will be relived for eternity inside the Rhino Club.

THE DIME GHOST

In 1862 yellow fever ravaged Wilmington. By its culmination 654 victims succumbed to the disease. At the peak of the devastation the daily number of people who died exceeded the total number of doctors in Wilmington. The corpses were stacked along South Fourth Street, behind St. James Churchyard, before being carted away to a mass grave in Oakdale Cemetery. The memory of these freshly strewn corpses was part of what kept anyone from building on South Fourth Street for over thirty years.

At the time of the yellow fever epidemic, Dr. Albert Baldwin was serving in the Confederate Army. He was a trained dentist, which essentially meant a surgeon. There's no record of how many limbs the doctor sawed off fully conscious young men, but the number was no doubt morose. At some point there would have been enough bloody carnage to render the image of neatly stacked bodies along a tree-lined street moot.

After the war Dr. Baldwin became a dentist in the modern sense of the word: concentrating on people's teeth. He purchased a residential lot on South Fourth Street, across the street from St.

James Churchyard and next door to the Temple of Israel, North Carolina's first synagogue.

In 1895 Dr. Albert Baldwin and his wife Emma moved into their newly built Queen Anne home. The spacious home featured a first floor dental office to accommodate the doctor's growing practice. It's not known how many teeth the good doctor extracted, but it was a considerable sum.

In 1909 Emma Baldwin died. Dr. Baldwin survived until 1934. Upon the doctor's passing his daughter, Lucy Baldwin, inherited the home. In 1936 she lost it to the bank. An insurance company purchased the home and kept it as investment property. It was the tenants who first discovered the Baldwins' lingering attachment to their house.

In the beginning it was teeth. A stray molar here, an incisor there, old teeth began appearing about the house. Initially the tenants thought this was perfectly normal: What else would you expect to find in an old dentist's home? But these teeth weren't found under floorboards or in an old box; they were being placed neatly about the house, on the fireplace mantel, the staircase, the kitchen counter, a bedroom dresser and at least once in a glass of water.

In the 1970s a new, unwelcome element began renting the home: unwed couples! The Victorian sensibilities of the Baldwin spirits certainly cringed at the looseness of their new boarders. So when these tenants began finding gifts they were anything but friendly in nature (it may be difficult to think of teeth as friendly in nature, but they are certainly non-threatening).

One young woman found her grandmother's wedding china smashed to pieces with a large dirty white marble. Other couples discovered large sewing needles plunged into their mattresses. Looped through the eye of the sewing needle were long strands of dirty, white thread. If these aren't metaphors, they don't exist!

In 1990 Glenn and Laurie Kaiser purchased the home. Though they initially experienced some ghostly resistance to their presence, this was resolved when Laurie, at the suggestion of a friend, had a little "chat" with Emma. Laurie invited the spirit of Emma to remain

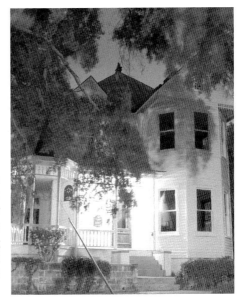

A photo of the Baldwin House shows an unusual "rope" light emanating from one of the bay windows. The Baldwin ghosts have a fondness for leaving occupants interesting and memorable gifts. *Courtesy of Nik Newton.*

in the home and be a part of the Kaiser family. It was upon this formal invitation that the Kaisers began finding gifts of their own. Dimes, ten-cent pieces, began appearing around the house. They were always left in unusual places, and always found on heads, completely rubbed clean of their shine, and almost always date significant. Over a fifteen-year period the family has found almost one thousand dimes in this manner. And behind each dime there is a story.

On October 8, 1990, the Kaisers found their first dime. Laurie found it in the upstairs bathroom sink. It was dated 1966. Glenn and Laurie were married on October 8, 1966! The dime was not the largest or most expensive gift the couple exchanged that day, but it was certainly the most cherished.

One afternoon, while one of their daughters was visiting from college, Glenn and Laurie had to run some errands. On the way out they reminded their daughter not to make a mess because they were entertaining company that evening. After her parents were gone, she made a sandwich and a fresh cup of tea. She took her lunch upstairs, deciding to clean the kitchen after a quick nap. An hour later she awoke to voices and footsteps coming up the staircase.

"Mom, Dad, is that you?" she called out. "I'm sorry for the mess in the kitchen; I'll clean it up in a sec."

No one answered.

"Mom, Dad, are you there?"

Then the voices and footsteps fell silent.

"Is there someone in here?" she called out, beginning to get a little nervous.

From just a few feet away she heard the rolling, pinging sound of something dropping into her teacup. As she craned her neck and looked into the empty mug, there was a dime!

She raced screaming out of the house, jumped into her car and sped away. When Glenn and Laurie returned a short time later they found the mess in the kitchen, but no daughter. Laurie was incensed, until her weeping daughter called and explained to her mother what had transpired. Then Laurie grew angry. How dare her children ever be frightened by these spirits, she raved to Glenn. It was completely unacceptable!

That evening, after a passing thunderstorm, Glenn and Laurie were sitting on the front porch with some friends.

"What's with the dimes?" one of the friends asked Glenn.

"Which dimes do you mean?" Glenn answered.

"Those dimes, on the railing behind you," the friend said.

Glenn and Laurie turned to find eight dimes, four stacks of two each, balanced on the railing behind them. It was the largest single cache of dimes they ever found at once, and Laurie immediately realized the dimes were left as an apology from Emma for frightening their child.

Sometimes the dimes are found off property. For example, departing guests of the Kaisers would often discover dimes inside their luggage upon returning home. One of their children actually found two dimes inside of her jewelry box, which she had not opened during her entire visit to her parents' home.

An even stranger occurrence took place in London, England. Laurie was on the last leg of a three-week swing through Europe. She was traveling alone and on the last night of her trip she booked a small

room in London, the kind that can easily be mistaken for a closet. The sparse room offered neither dresser nor clothes rack, and with the cramped quarters there was nowhere to leave her suitcase except up against her room's main door.

That evening, exhausted and missing her family terribly, Laurie put her nightgown on, placed her suitcase back against the bedroom door, and then climbed into bed and cried herself to sleep. When she awoke the next morning an American dime was resting on top of her suitcase. With her suitcase blocking the door there was no way anyone could have entered the room, and Laurie had no American currency with her! She said it was such a wonderful moment, to realize she really wasn't traveling alone.

In March of 2005 Laurie was cleaning out an old dresser drawer. Among the debris were several aged spools of thread. Admittedly she didn't sew much, so she retrieved her sewing box down from the top shelf of the closet. When she opened the box there were two dimes in the bottom, on heads, no shine. One was dated 1966, the year Glenn and Laurie were married, and the other was dated 1990, the year they bought the home. She said the last time she opened that sewing box was when they first moved into the home, in 1990!

A few months later the television in Dr. Baldwin's old office failed. Laurie ordered a new television. When the delivery people removed her old set there was an inch of dust under the TV.

"I'm not much of a duster," she laughed, running off to get a towel.

As she wiped up the dust there was a loud, scraping noise against the wood. She reached into the dust and extracted a dime, on heads, rubbed clean of its shine. The date of the dime was 1991, the year the original television was placed there!

There have also been many occurrences experienced by guests of the Ghost Walk. But the one that gives the biggest hair-raising goose bumps occurred on July 9, 2003. John Henry Scott was preparing to leave with his group when he noticed a family running down Market Street. Suspecting they were there for the tour John momentarily hesitated. A huffing and puffing father, mother and

two young boys stopped in front of John, drenched in sweat from their jog.

"I'm sorry we're late," the father apologized, still catching his breath. "Our flight from Colorado was late. It's our first time in North Carolina and we're only in Wilmington for one night. We nearly killed ourselves to get down here in time."

"Well I appreciate your enthusiasm," John laughed as his group headed out.

In between stops the father of the two boys told John how excited he was to be walking Wilmington's old streets. He explained how his great-grandparents, who were farmers of Scottish descent, originally lived in the Cape Fear area before moving west in the late 1800s. Though he himself had never visited North Carolina it was thrilling to actually walk the same streets that his great descendants may have walked.

Later, the group was at the Baldwin house and John was talking about the dimes.

"You mean like those two?" the father interrupted.

"Excuse me?" John asked.

"Do you mean dimes like those two, over there on the brick walkway?"

John turned and for the first time noticed two dimes on the edge of the shadow line of the walkway.

"I saw them too," a slightly embarrassed elderly woman chimed in. "I thought they were part of the tour."

John picked up the dimes, noticing they were both on heads and rubbed completely clear of their shine.

"They're not part of the tour," John said, thinking to himself what a great conversation piece he now had!

But John realized he wasn't the one who spotted the dimes, so he turned to hand them to the surprised father.

"I'll tell you what. I'll give you these dimes if you promise me you will never spend them. This isn't the sort of money you spend. These are souvenirs for you to keep."

"Well, thank you," the astonished father remarked. "Look, I promise you we will never spend these dimes. In fact, when I get back

to Colorado I'll lock them away for safekeeping. And when my two boys are old enough and responsible enough I'll give one to each of them, and I'll recount for them what took place out here this evening. But I promise we will never ever spend these dimes."

Then he looked down at the two dimes and gasped.

"What's wrong?" his wife cried in concern.

The father began to weep, backing away from the group. With his trembling hands he held the dimes up for his wife to see.

"Oh my god!" she cried, "These are the birth years of our children!"

The dimes are almost always significant dates to the finder!

A special treat for guests of the Ghost Walk was when Laurie or one of her children would come out onto the front porch and share some of their personal experiences with the group. The family didn't have to do this, but they are good people, and very proud of their extended family. But after Glenn passed away, after Laurie's children were grown and with lives of their own, the home became too big for her. In 2006 the family sold it (incredibly there is a huge demand for authentically haunted homes).

And though Laurie and her children are never far away, I think I speak for Dr. Albert and Emma Baldwin when I say they will be greatly missed.

THE BELLAMY MANSION

Dr. John Bellamy belonged to the South's wealthy planter class. As owner of a substantial plantation in Brunswick County and an even more profitable turpentine plantation in Columbus County, he had a sizable slave holding. He was also director of a local bank and railroad. With such a vested interest in the Southern economy Dr. Bellamy was a staunch supporter of Southern secession long before it was *en vogue*.

By March of 1861 Dr. Bellamy and his wife, Eliza, had moved into their newly completed twenty-two room, ten-thousand-square-foot Italianate/Greek Revival home. The neoclassical home featured a three-story portico supported by fourteen Corinthian columns. The window, door and cornice work was exquisite and richly detailed. On the top of the home sat a belvedere with beautiful arched windows. For entertaining and ventilation purposes immense pocket windows were installed to allow guests and air to flow freely from anywhere along the ten-foot-wide colonnaded porch wrapping around three sides of the home, into any of the

first floor rooms. Once inside, guests encountered spacious, lavishly decorated rooms. On the fourth floor a small interior space was built that John and Eliza's nine surviving children used for performances. A detached carriage house and a slave quarters were also built on the rear of the property.

On May 20, 1861, less than three months after moving into their new home, North Carolina became the last state to secede from the union. The fabric of the city seemed to transform overnight. By year's end profiteers, prostitutes, smugglers and rogues of every description filled the Wilmington waterfront. Then rumors of a Union invasion began to circulate throughout the city. Dr. Bellamy made plans to evacuate his family inland. In the summer of 1862, as the pestilent shroud of yellow fever began to blanket the community, the Bellamy family fled.

It wasn't until February 22, 1865, that Wilmington fell. The Bellamy Mansion was commandeered and became home to the Union military staff. By spring it was evident that the Confederacy was doomed. Soon after Lee's surrender, Dr. Bellamy applied for permission to return to his occupied home, but as a known, longstanding proponent of secession, permission was denied. After a tedious process Dr. Bellamy was able to secure a meeting with the Secretary of State William H. Steward and, upon signing an oath of allegiance to the Union and promising to never again use or acquire slaves, he received a pardon from President Andrew Johnson.

The home remained in the Bellamy family until 1972, when it was given to a newly formed nonprofit group to restore and open as a museum. Since then the home has been fully restored. In addition, a reconstructed carriage house has been built to replace the one lost to a hurricane in 1946, and the Italianate slave house is being renovated. The magnificent home is now a stewardship property of Preservation North Carolina, and is open to the public in its full splendor. But when touring the home scant mention will be made as to the spirits that dwell there. Rightly so, since the museum's main function is to preserve and educate the public about the history of Wilmington and those who lived and worked in this house, not the spectral phenomenon. Nonetheless the ghosts are there.

As to where these ghosts come from, well, that is a mystery. There is scant little death associated with the home. Certainly none of the known deaths were violent or painful. There were the skeletal remains found by the Bellamy servants early one morning, resting atop the old ironing board. But the skeleton was part of a prank Willie Bellamy enjoyed playing. At the time he was studying medicine and took great pleasure in propping his articulated skeleton in unusual places for skittish servants and family members to find.

Or maybe the spirits can be attributed to the Union occupation of the home. All sorts of stories are told about that time in the life of the house. Reportedly, the Union officers would often indulge in raucous parties where vast amounts of alcohol were consumed and women of ill repute were almost always present. Supposedly during one such party a young pregnant prostitute went into labor and gave birth on Dr. and Mrs. Bellamy's high-post bedstead! Who knows what sort of savage and tempestuous behavior transpired behind closed doors?

Or perhaps the spirits were there long before the Bellamy Mansion was built, and were remnants of an earlier time. In 2001 an archeologist investigating the old slave quarters removed several floorboards to discover a neat stack of buttons. The buttons were arranged in such a careful manner it's believed they were placed there by the enslaved builders intended as a blessing of the quarters in accordance with West African tradition, in order to keep evil spirits at bay!

In 1972, just weeks after the Bellamy was donated to the nonprofit group wishing to restore the home, arson befell the home. It wasn't until 1989 that efforts were made to open the house to the public. It took five years for the work to be completed. It was during this renovation period that several strange ghostly encounters transpired.

In the early 1990s a film company was wrapping up a shoot in the interior of the mansion. A location scout and assistant were alone in the home, exploring the interior, when they stumbled into the old library. At the time the library was being used as a storage room. Box upon box of old Bellamy family papers were piled from floor to ceiling.

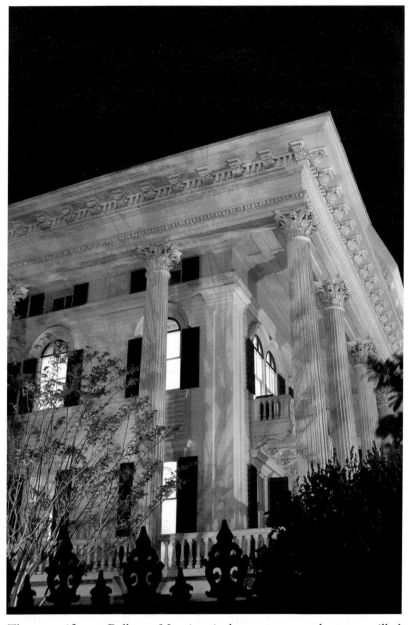

The magnificent Bellamy Mansion is home to several strong-willed spirits. Guests who visit the mansion often find themselves mysteriously drawn into the belvedere atop the house.

Curiosity led the two men to begin perusing the old dusty files, when suddenly they heard the front door slam shut. They thought it was a security guard coming to lock up the house. Heavy footsteps thundered down the hallway and stopped outside the library's closed door.

Suddenly the library door burst open and smashed against the plaster wall. There was no one there! Then a cold blast of air rushed into the room, sending the stacks of paper swirling around the room.

The two panicked and, feeling a presence on their heels, they ran out of the room, down the hall and burst out the front door, jumping down the entire staircase to the sidewalk below. The front door slammed shut and a terrible noise erupted from the house; a commotion that sounded like two fists began pounding against the front door with such a force as to rattle the first floor windows. The film scout and assistant refused to go back into the home!

Shortly after this occurrence the Bellamy Mansion played host to some Civil War re-enactors. They camped in the house for just one evening. In the thick of the night, one by one, a Union soldier began prodding the re-enactors awake. Without uttering a word, the Union man offered the weary re-enactor only a puzzled gaze before walking away.

In the morning the re-enactors gathered in the large dining hall, wondering which of the Union re-enactors was responsible for waking them the night before. But as they looked around there wasn't a Union man amongst them. The Union soldiers were all camped up the road at St. Paul's Lutheran Church! The spirit of this poor, lost Union soldier must have been perplexed with the presence of so many Confederate troops in his home.

During a fundraiser in 1993, a guest and her husband began to explore the old home. Off the rear porch they discovered an old servants' stairway leading to the basement floor. Intrigued, the couple began to descend the dark, narrow staircase. On the way down a rush of cold, stale air raced past them and the wife began to experience terrifying visions. She envisioned a dead slave girl locked in the stairwell. The girl was badly beaten and lying in a pool of

blood. The woman screamed, stopping the awful vision, and ran away from the home.

After the home opened to the public in 1994, spectral events involving the spirit of Miss Ellen Bellamy began to occur. Miss Ellen was the last of the Bellamys to live in the home. She died in 1946, in her ninety-fourth year. In her later years she used to lie in bed reading the newspaper. The ink residue of the paper would rub off on her hands, and at night when she reached up to turn off the wall sconce this inky deposit would end up on the wall. Over time this black stain built up.

Since Miss Ellen's passing the room has been painted many times. Yet more than sixty years after her death her fingerprints still return. Every so often when the home is preparing to open someone will discover the fresh inky smudge marks near this old wall sconce!

And then there's Miss Ellen's wheelchair. From time to time the staff will discover the chair has been moved from one room to another. Since the Bellamy can be rented for wedding receptions and other social functions it's thought a late night reveler is responsible for relocating the chair. But the guests of the Bellamy often have a conflicting account of events. Sometimes guests feel as though the chair is following them. Where they may recall seeing it in one particular corner of a room, a few moments later it appears elsewhere. Some guests have claimed to hear a squeaky wheel of the chair rolling down the hallway. Others have said that while turning around, they stumble over the chair, which unexpectedly had appeared behind them. For many, simply being around the chair creates a feeling of unease. A strong presence is clearly felt lingering about it.

After the guests have gone, when the home is darkened and locked up for the night, the spirits seem to come to life. Over the last few decades a gray-haired couple has been seen standing in the sable glass of the third-floor windows. The man is dressed in a military uniform and the woman in a flared antebellum gown. On other occasions a murky white skull has been seen peering out one of the back windows. Photos of the home often catch strange figures in the windows, including faces and hands.

And then there are the children. The faces of small children have been seen gazing out of the fourth-floor window overlooking Market Street. This is where the children's stage is located, where the Bellamy children would play for hours on end. The small, gaunt faces stare blankly ahead. Those who have seen the children say their pained look is enough to keep them from ever walking by the home again. On some nights the children have been seen in the belvedere on top of the house.

A visit to the Bellamy Mansion is a step back in time. There one can peruse the lonely rooms of the basement or revel in the lavishness of the architecture. Or for the brave of heart, a journey up to the fourth floor of the home may be in order. And while there, perhaps while gazing at the old children's stage, you may feel a presence, urging you up into the belvedere. And you may ascend the narrow staircase, filled with consternation and fear. But once in there, you can close your eyes, and you will feel the spirits of the Bellamy Mansion all around you.

THE OLD FLOPHOUSE

On Grace Street there is a battered yellow home with an ambiguous history. The Susan Moore House was built in 1898 in an area that was heavily industrial, dominated by railroad and port infrastructure. With a shotgun floor plan, and over twenty individual rooms, it's likely the home was constructed as a flophouse.

Boarders were the dregs of society: rejects, outcasts, transients, drug addicts, drunks and the destitute. Their daily drudgery and meager existence created an atmosphere teeming with rage. The constant tension would often erupt into violence over a simple matter, such as a missing comb or a misperceived look. Fists would fly, knives would slash and the bodies would fall. Others left of their own accord, with a slit wrist, a mouthful of pills or burned to death after passing out in bed with a lit cigarette.

Steeped in violence, the home had its share of nameless victims, and thus harbors a few anonymous spirits. Though most of the occurrences are typical, run-of-the-mill events, some encounters stand out.

A young married couple rented a portion of the home in the early 1980s. They owned two large golden retrievers with rambunctious personalities. Sometimes the animals slipped into what the owner referred to as "freak out mode," which resulted in the seemingly possessed dogs racing wildly through the house, crashing into walls and furniture, each with their favorite chewy toy grasped firmly between their slobbering jaws.

To calm the dogs, the owners simply took away the gnawed playthings, thus breaking the spell. After moving in there was a particularly destructive episode that led to some broken furniture. The dogs were made to sit in the kitchen and their chew treats were placed on top of the refrigerator. Ten minutes later the husband found the dogs chomping away on their toys.

"Why did you give them their treats back?" the husband asked his wife.

"I didn't give them back," she answered.

"Then how did they get them? They certainly can't reach the top of the refrigerator on their own."

"I don't know, but I didn't do it."

This was about the time the wife began to notice the dogs' erratic behavior. Sometimes they would sit side by side in the hallway, panting and with their tales wagging, looking up at the ceiling. She also began to discover their chew toys left in unusual places, difficult to reach places, like behind the couch or on top of a dresser.

A few weeks later the rampaging animals did more damage. The wife placed the treats on the top shelf of her closet and shut the door. The whimpering dogs hid out in the kitchen as she went about cleaning the mess. Within just a few minutes the amiable dogs came trotting back into the living room, each with his favorite toy clenched between his teeth! The startled wife stumbled into her bedroom and saw the closet door was closed.

She packed her bags and told her husband the house was too haunted and she refused to sleep there another night. After she left for a friend's house, the husband put the dogs' toys on the closet shelf and shut the door. He then ushered the dogs from the room, closed

The old flophouse has seen its share of violence. It's in the upper windows that passersby have witnessed a broad-shouldered ghost in a black pea coat.

the bedroom door and began a vigil. As dusk intruded, the room grew leaden, and as objects lost their clarity he drifted off to sleep.

He awoke with a dry mouth and stiff neck. He got up from his chair and, on the way to get something cold to drink, he noticed the closet door remained closed. When he opened the bedroom door, his napping dogs were sprawled out in the hallway.

Beside them were their toys!

They never spent another night in that home.

Some of the occurrences were much more violent in nature. The most startling of these involves vagrants, who in the 1990s would break into the abandoned, dilapidated house and abuse themselves into oblivion.

Some of the poor, inebriated trespassers were then jolted awake with kicks to the face, stomach and groin. The pummeling was brief, as most of the men soon passed out in a pool of blood and vomit. But

during the beating, even in the dimly lit house, no one stood above these victims! An invisible force delivered the punishment and each blow seemed to materialize out of thin air. Yet during it all there was an observer. Before losing consciousness, several men reported seeing a broad-shouldered blond-haired man in a pea coat leaning against a wall ten feet away.

Were the beatings merely drug-induced hallucinations? Could they have been the result of some miscreant who took pleasure in abusing the homeless? Or was it simply a wayward flophouse spirit, incensed over the intrusion? The answer may never be known; however the break-ins soon stopped.

The tension in the home is powerful and often radiates outward. Guests of the Ghost Walk often refuse to approach the home. Some who approach become overwhelmed with dread and have to step away. Zach "Oswald" Ozmar, a Ghost Walk guide, thinks he understands why. As one of his favorite haunted sites, he leads many of his tours past the home. He escorts his group onto the lawn, just a few feet shy of the front porch, and with his back to the structure, he begins speaking. At some point he'll casually mention that the second floor of the home remains vacant. That's when the curious look up.

In an unlit second-floor window, behind the yellowed lace curtains, a broad-shouldered man in a dark coat stares back at them.

That's when the screaming and running begins, and that's why many who pass by this home give it a wide berth.

CAPTAIN, CAPTAIN AND SILVERSMITH

The golden age of piracy lasted for twenty years, culminating with the deaths of two of the day's most notorious pirates: Edward "Blackbeard" Teach, killed and beheaded at Okracoke Island, 120 miles north of Wilmington in November of 1718, and Stede "The Gentleman Pirate" Bonnet, captured on the Cape Fear River south of the port of Wilmington and hanged in December of 1718.

For the same reason pirates like Blackbeard and Stede Bonnet were attracted to our shores, latter-day smugglers were attracted as well. With a sparse population, scores of inlets and marsh areas to hide in and a colonial politic that turned a blind eye to such illegal activities, North Carolina was considered home to many sea-going rogues. In Wilmington, smugglers constructed a network of safe houses, storage buildings and hideouts, including several caves tunneled into rivers' sandy bluffs. An old brick tunnel, reportedly ten feet high by ten feet wide, ran into the hillside near present-day Castle Street. The legend of Wilmington's tunnel system, and what if anything is hidden in them, is hotly debated to this day.

Responding to the disruptive nature of piracy and smuggling, the new United States government was forced to act. Under orders from President George Washington, Secretary of the Treasury Alexander Hamilton started the Revenue Cutter Service, precursor to today's Coast Guard. As the largest city in North Carolina, Wilmington was the logical place to homeport a ship. And so construction of the U.S. cutter *Diligence* began in 1791 in Washington, North Carolina (the first town to be named after General Washington, in 1775). President Washington authorized and Thomas Jefferson signed the commission for the *Diligence*'s first master, Captain William Cooke. The present-day *Diligence* is the sixth cutter to carry that name, and is the only active Coast Guard cutter named after one of the first ten revenue cutters still in its original homeport.

Though Captain Cooke's history with the *Diligence* is well documented, his life in Wilmington, including his place of residence, is a little less clear.

Possibly while acting as a squatter on land he did not own, Captain Cooke built his home in 1784. The home is a simple dormered cottage known locally as a Wilmington Plain House. The two-story frame home features a detached kitchen and a candle shop, the latter also being used as sleeping quarters for one of the captain's slaves. There was also a small basement and root cellar. Oddly, the home sits perpendicular to the street with its narrow side facing the roadway. Though some believe the home was built this way for tax purposes, in order to reduce its "frontage," the more likely explanation is the home was built this way because at the time there were no other homes around it and "street frontage" was ambiguous at best.

Captain Cooke's impact against smuggling in the Cape Fear region was profound and immediate. He was quick to seize and impound ships found to have outdated or forged papers, or for any other suspicious violation. In 1793 he seized a French privateer and $35,000 worth of stolen Spanish gold (with a present-day value of over $11 million). Though he claimed the gold for the United States, legend says he kept a portion for himself, hiding it in one of the underground tunnels that connects to his house.

But Captain Cooke's success proved his undoing. As his reputation grew, the smuggling syndicates recognized the threat to their livelihoods. In 1796 Captain Cooke and his son vanished, believed kidnapped by a band of cutthroat smugglers, then murdered and their bodies dumped at sea.

Fifty years later another sea captain by the name of Silas Martin purchased the old Cooke home. Captain Martin was a wealthy merchant with a deep love of the sea. As his children grew into adulthood he dreamed of taking them on a journey to circumnavigate the world. By 1857 Captain Martin had secured contracts at various ports of call throughout the world in order to finance just such a journey. Over the objections of his wife, Captain Martin, his eldest son, John, and his third child, Nance, decided to set sail on what was to be a most memorable adventure.

At the first sign of spring they set sail aboard a fast four-masted clipper. As the clipper breached the Frying Pan shoals at the mouth

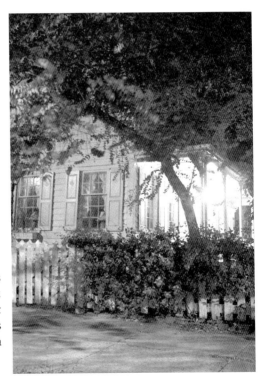

The Cooke House has seen its share of misery. Yet despite the death that often visited the home's inhabitants, it remains a warm, inviting home.

of the Cape Fear River, a stern breeze snapped the canvas taut and the clipper bowed its nose and drew them into the vastness of the Atlantic.

In early May, having visited numerous ports on what was thus far a profitable venture, Nance began to show signs of sickness. Her father didn't believe it was anything serious, and the salt air and open sea would certainly revive her spirits soon. But by late May her condition began to worsen. On May 25, while docked in port in Cardenas, Cuba, Nance succumbed to her wretched fever. She was just twenty-four years old.

The loss of Nance was only part of his grief. Captain Martin promised his daughter he would take her home, and the idea of burying her at sea or in a foreign land weighed heavily on him. But at the time there was no way short of mummification to preserve her remains for the long journey home. So the captain and his son came up with a plan to bring Nance's body home.

First, before rigor mortis set in, they tied her frail body to a stout oak chair. They then secured a large hogshead oak cask and emptied it of its contents. They placed her delicate body, securely tied to the chair, into the hogshead cask, in hopes the chair would prevent her body from sloshing around. They then filled the cask with rum, whiskey and other distilled spirits in order to preserve it, and then sealed the cask. Captain Martin notified his son it was time to return home and break the news of Nance's death to his wife.

John Martin looked at his father uneasily. "We can't sail home, father, not now."

"For Heaven's sake, why not?" Captain Martin asked irritably.

"We have contracts we must honor. If we fail to meet these obligations we'll be sued. We could lose the whole business."

The captain realized his son was right. So with much remiss, the captain wrote to his wife about the unfortunate death of their daughter, promising to bring her body back home for proper burial, and then he and his son headed back out to sea.

With Nance firmly secured below decks, the captain began to fulfill the remainder of his contracts. One evening in September of 1857,

Captain Martin bid his son goodnight and headed below decks to retire. The next morning the boy was nowhere to be found. The ship was searched from stem to stern. All signs indicated he did not sleep in his bunk that night. Believing the boy had been washed overboard during a passing storm the previous night, the clipper retraced its route for a considerable distance, but John Martin's remains were never found.

Stricken with the loss of two children, the Captain reneged on his remaining contracts and returned to Wilmington. Unsure what affect the rum and whiskey had on poor Nance's body, Captain Martin and his wife decided to bury her in the hogshead cask, as she remains to this day, in Oakdale Cemetery.

Then in 1866, William Anderson, a prominent silversmith, purchased the old Cooke home. Anderson was a gifted and successful artisan before the Civil War and many of his original works are owned by local families. But with the collapse of the South's economy after the war, few people could afford fine silver. Several poor business decisions led him into a debt from which he knew he could never recover. On June 16, 1871, in debt and in ill health, William Anderson methodically extinguished all the gaslights in the house. He then quietly stepped into the backyard and placed a stool beneath the outstretched limbs of a pecan tree. Draping a rope over a sturdy limb he slipped his neck into the noose and, in perhaps the loneliest of all acts, he stepped off the stool. The next morning he was found stiffly dangling among the young pecans, which were only beginning to fruit.

Today, passersby of the Cooke House may experience soothing warmth and brightness radiating from the cottage. There is an impregnable calm that emanates from the walls of a home that has bore witness to so much suffering. And with five tragic deaths it's no surprise the spiritual residue of these poor souls still lingers behind. Though one can argue which individual spirit is behind each occurrence, whether it is the ghost of Captain William Cooke or his son, or perhaps Nance, John or Captain Silas Martin, or the lone spirit of William Anderson, as to the presence of these souls there is no doubt.

It is not uncommon for a spirit to travel many miles from the site where the trauma of death took place, to a more familiar ground. The first inclination of many people who are confronted with danger or death is to return to the comfort of home. Perhaps for Captain Cooke it was while witnessing the torture and gruesome murder of his son. Just moments away from his own painful death, the captain surely retreated deep into his mind, to happier times, perhaps to a memory of playing with his son in the very walls of the home he so desperately sought. It is more than feasible to believe the captain's last living thought involved his returning home. Home is a place of safety.

The same can be said of Nance and John Martin. Young Nance had never before been to sea. While delirious with fever she no doubt begged her father to take her home. Captain Martin himself promised to bring his daughter home, not to abandon her to the cold dark depths of the sea. Captain Martin and his son talked openly about the importance of "taking Nance back home." And when John Martin was washed overboard, drifting alone in the wide expanse of an unforgiving ocean, he would have remembered his father's words: how above all else, they must return home.

Captain Martin understood the importance of bringing his children home, both physically and spiritually. Upon his return the captain would often retreat to his parlor for hours on end, lamenting his decision to take his children to sea. On dark, stormy nights, when driving rain and howling wind rattled the house shutters, the captain would muffle his ears against the crying out of his son, begging him to come save him.

Both Captain Martin and his wife shared in another experience, this one attributed to their daughter, Nance. In the evening, from the hallway just outside their bedroom door, the couple could hear light footsteps pacing back and forth. They knew this was the ghost of Nance, coming to visit her mother.

The grief was so great for Captain Martin that he never returned to sea. He became Wilmington's port warden before dying of grief in 1861.

But not only did Captain Martin and his wife hear Nance's footsteps. Many occupants of the home have heard them. Past owners of the home have described hearing these steps on many occasions.

One evening a guest, on their first night in the home, heard footsteps on the landing outside their bedroom door. At breakfast the following morning they brought this up with the owner.

"Were you having a hard time sleeping last night?" the guests asked the owner of the home.

"What do you mean?" the owner asked in surprise.

"Well I heard you pacing back and forth last night. I was going to get up, but I didn't know if you wanted company!"

A nursemaid who lived and worked in the home in the 1970s refused to let the children play upstairs. The sound of Nance's pacing so unnerved the poor girl that she was never able to feel comfortable leaving the children out of her sight, knowing they were never truly alone.

Still, other homeowners who have heard the strange moaning on stormy nights attribute it to the ghost of William Anderson. One owner went so far as to cut the lower branches off the pecan tree William hanged himself from, in order to stop the tormented cries.

Another occurrence attributed to the spirit of William Anderson involves the lighting on the second floor. Light bulbs on the second floor fizzle and burn out at an alarming rate. Though the home has been completely rewired, the problem still persists. Could it be the ghost of William Anderson, extinguishing the lights in the house, to prevent anyone from bearing witness to his desperate act?

Then there's Captain Cooke. His levitating apparition has been seen loitering in both the sitting room and the living room, enveloped in a sapphirine haze. Others have caught a brief glimpse of the captain as they enter the sitting room, sans his black-blue aura. And still many claim to feel the actual presence of the captain whenever they are in the room.

In the spring of 2001 John Henry Scott, a guide for the Ghost Walk of Old Wilmington, arrived outside the Cooke House with a private

tour group from Chicago. After he spoke of the story of Captain Cooke, before beginning the Captain Martin portion of the story, a guest's cell phone began ringing.

"Oh my goodness, I am so sorry! I thought I turned off my phone," the man stammered.

"It's okay," John assured him. "I'll stop for a second if you need to answer it."

"I'm sorry! Let me tell them I'll call them back after the tour."

"Hello?" he answered. "Excuse me…Who…I'm sorry, there's no one here by that name."

He hung up the phone, looking fallow, and began trembling.

"Is everything all right?" his wife asked him.

"It was a wrong number. They were looking to speak with someone named Cooke! I don't know anyone by that name."

A few weeks later John was by the house with another group. He quickly glanced at his digital watch to make sure he wasn't running behind.

"This is odd," he muttered as the group gathered around him. "My watch is doing something strange."

He took off his watch and began passing it around the group. The numbers on the watch were rapidly flashing around at random.

"I've never had that happen before," John said, while one of the women in the group kept hold of the watch.

John then shared the story of the Cooke House. When he was done he began to walk away from the house. The woman who was holding the watch began to follow and then inadvertently glanced down at the timepiece. She screamed and dropped the watch to the ground.

"It stopped!" she cried. The watch had reset itself to the correct time.

Is this coincidence? Perhaps! Still, the Cooke home has occasioned visits from these wayward spirits. So if you catch yourself strolling through the neighborhood on a stormy night, pay close attention. Through the driving rain you just may see the sapphirine enveloped image of Captain Cooke sauntering by, or perhaps that of the beautiful young Nance Martin. When the thunder cracks and lightning flashes, you may catch a glimpse of the indelible image of poor Mr. Anderson swinging from a tree limb. Then, as the

reverberating thunder fades, begin to listen. Listen carefully. For on those dark, ominous nights you may very well hear the wind whispering for you.

HOPSCOTCH AND JACKS

W illiam Holloday was not only grieving over the loss of his twenty-five-year-old wife, Maggie, who died during childbirth, but over the loss of his two young children, who went to live with his in-laws after his wife's death. So when he moved into his new home on Third Street in 1891, it must have felt sickeningly empty. In 1895 he sold the home to William Whitehead, whose family occupied the home for the next seventy-five years.

In a time before TV, before video games and iPods, before the fear that there were deranged psychopaths living in the neighborhood, children used to play outside. However, playing jacks, riding bikes or a game of hopscotch demanded smooth surfaces, not the uneven sand, wood planking, brick or stone slabs that made up Wilmington's original sidewalks. So when the first concrete sidewalk was poured in front of the Whitehead house, it was an instant hit.

Children flocked to this ninety-foot stretch of sidewalk from blocks around. From dawn until dusk the incessant, contagious

laughter of children permeated this beautiful tree-lined expanse. Homeowners would watch the children play for hours on end. But as the years passed other concrete sidewalks were added and the children moved on. Or did they?

In 1971 Robert and Florence Hughes purchased the home, and even though they had eighteen children of their own, at times there seemed to be one or two extra!

Once a week, Mr. Hughes would leave work and return home to have lunch with his wife. Occasionally he would notice spilled cereal on the kitchen floor. He knew his wife was meticulous, even with eighteen children rampaging around the house, and so he was puzzled by this. One day he asked which of the children was making the mess and she casually responded that it wasn't their children making the mess, but rather one of the "others."

"Ah," Mr. Hughes thought to himself, "the stress of eighteen children has finally caught up with the poor woman."

One morning Mr. Hughes found himself in an empty home, as the rest of the family was away visiting relatives. He poured a fresh mug of coffee and then went outside to fetch the morning paper. When he returned to the kitchen a few minutes later he found fresh cereal spread across the table and floor. He never doubted his wife again!

On January 2, 1975, the Hughes Family sold the home. The new owner was a recently divorced fifty-year-old man from Massachusetts. He had closed on his new home in his new city of residence at the beginning of a new year. It seemed like the perfect way to begin his life anew.

But one can only speculate as to the emotional pain of leaving those you love behind, especially children. Perhaps the ghostly sights and sounds of other children in his new home were just too unbearable, but we'll never know. For on the night of July 31, 1976, he shot himself to death.

Since then, no family has stayed in this home long. In fact few have stayed for more than a year. But that changed in the autumn of 2003.

For over forty years, Linda and Bunky Bruce have dreamed about finding the perfect historic home. They have scoured the eastern

seaboard, looking for this perfect home, but to no avail. Then they discovered Wilmington.

One day, while innocently strolling along the streets of the historic Port City, they stumbled across the Holloday-Whitehead House. There was no For Sale sign, but that didn't stop them from approaching the owner. It took a year of effort, but Linda and Bunky finally owned their dream home. Immediately they began an eight-month renovation process during which they discovered why they needed to live there.

As their priest blessed their new home he confided in them that if there were any spirits present, the blessing would drive away the bad but not the good, especially child spirits. Children, he explained, usually go to the place where they felt happiest and safest, so they don't tend to leave easily. No one appreciated the relevance of this statement at the time.

Soon the home filled with the cacophony of buzzing sanders, whirring saws and pounding hammers. Delivery people and workmen shouted to be heard above the din, and in the chaos, no one seemed to notice anything unusual. But by winter the bustle in the house began to wane.

One rainy gray winter's day a workman was alone in the house, tediously stripping the last of a half-dozen layers of paint from the ornamental mantelpiece in the middle parlor. The acrid tang of the heat-stripped paint had long ago dulled his senses, so it took him several minutes to identify the unmistakable fragrance of rose perfume being emitted from the melting paint. Then the hair on his neck began to rise as he sensed he was no longer alone in the room. As he turned he was startled to see a little girl, perhaps seven or eight years old, with curly, sand-colored hair, standing behind him. Her hands were by her side, clinging to the long white cotton dress that adorned her. Then with a twirl she skipped off down the hallway and vanished. This was the first of several encounters with this playful girl.

About this time contractors began complaining that whenever they were upstairs working, the doorbell would ring; only after traipsing downstairs, there was no one ever there. To cure the problem, Bunky disconnected the wiring to the ringer.

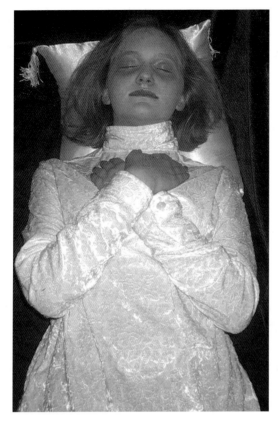

The Holloday-Whitehead House contains the playful spirit of a little girl. She is often seen in the house, and has a fondness for hiding things. She has been adopted by the current owners.

"There," he told Linda while standing beneath the bell in the kitchen, "now it can't ring!"

And then the doorbell rang. And it rang two more times in rapid succession.

Bunky's ire overrode his shock as he raced to the front door. Of course there was no one there. He began depressing the doorbell over and over again, to complete silence, muttering how this was further proof the doorbell couldn't ring (though it indeed had rung just a moment earlier).

Like all children, the youthful spirit that resides in their home is playful. This was never more evident than during Azalea Festival Weekend, when the whole city turns out for the spring's riverfront

hoopla. On her way to play hostess at one of the historical homes, Linda stopped by the vacant house. She unlocked the front door, stepped inside, locked the door behind her, and placed her keys on a sawhorse in the hallway right next to the front door. A few minutes later, upon returning from the first-floor powder room, she found her keys had vanished!

She frantically began to search under the sawhorse, up and down the hall, all throughout the first floor, but they were nowhere to be found! Dismayed she plopped on the stairs and pleaded aloud, "Please, I'm late and I need to get going. I don't have time to play." And there were her keys. They were halfway up the stairs, lying against the inside railing wall. She had not been to the second floor!

It was just after this occurrence when a neighbor showed Linda and Bunky a local book that described Wilmington's first concrete sidewalk, and how it ran directly in front of their home. They were especially enthralled by the description of all the children that once played there.

Another day a kindly man with large tortoiseshell glasses and a thick head of salt and pepper hair stopped by the house. He introduced himself as Robert Hughes, a previous owner of the home. Though he and his wife no longer lived in Wilmington, she still had doctors that she saw in town. Noticing all the work being done on his old home, he decided to stop by and introduce himself.

The first question he asked Bunky was if he had met the children yet!

The rest of their conversation was a blur, as Bunky couldn't get his mind off the children Mr. Hughes referenced. In fact he was so distracted he didn't realize until much later that he failed to get Mr. Hughes's phone number. He was crushed because he wanted to ask Mr. Hughes more questions about the children but realized he would probably never see him again.

On July 22, 2005, my wife, Kim, and I met with Linda and Bunky. We interviewed them as well as several of the contractors who had encountered the little girl in the home. And after a few hours of taking photos and interviewing spectral witnesses, Kim and I were convinced

that this was a worthwhile story to pursue, and in the morning we would begin doing our research behind the history of the home.

As Bunky escorted us to the front door he stopped and said, "That's odd."

An older woman in a white blouse was standing at the knee wall out front of the home.

"That's the neighbor who showed us the book that described the first sidewalks in Wilmington."

While introducing us, a long blue Lincoln Continental pulled up to the curb beside us.

"Now this is really odd!" Bunky muttered, calling out to the driver. "I didn't think I'd ever see you again. I can't believe you stopped by at this moment!"

"I'm just out for a pleasure drive and thought I'd swing through Wilmington," Robert Hughes answered, getting out from his car.

Then Bunky turned to me and asked, "Have I been calling you Robert all day?"

I nodded. He had indeed called me Robert several times.

"Well it must be because I sensed Robert would be stopping by!" he laughed.

To consecrate the moment I took a photo of everyone sitting on the front wall. Then I stepped to the side and took a photo of the front of the house. This photo would later help seal my belief that our being together at that moment was part of a long string of events that began in 1891.

"You know," Bunky said, pulling me to the side away from everyone. "Linda and I have been wondering why we were so drawn to this house, why we worked so hard to buy it."

He paused, then after a moment of reflection he added, "You know, we don't have any children of our own. Yet everywhere we've ever lived, our home was always the one the neighborhood kids would play at. Perhaps our affinity with children is what drew us here."

Later that night, I was looking at the photos I had taken of the house. When I came to the picture of everyone sitting on the wall, I stared at it and thought about Bunky's words. Perhaps it was their

ability to connect to children that caused them to buy the home. Then I scrolled to the last picture. Immediately I saw something that looked out of place in one of the windows. The reflection in the left pane of glass didn't match the reflection in the right pane. When I zoomed in, there was the faint image of a child staring out at me!

This is a story that was meant to be told. It is the story of a lost, lonely child and a couple that spent forty years looking for the perfect home, only to find a family!

BIBLIOGRAPHY

Cashman, Diane Cobb. *Cape Fear Adventure: An Illustrated History of Wilmington*. Woodland Hills, CA: Windsor Publications, 1982.

Cecelski, David S., and Timothy B. Tyson. *Democracy Betrayed, The Wilmington Race Riot of 1898 and its Legacy*. Chapel Hill: The University of North Carolina Press, 1998.

Hall, Lewis Philip. *Land of the Golden River, Volume One: Old Times on the Seacoast, 1526 to 1970*. Wilmington, NC: privately printed, 1975.

————. *Land of the Golden River, Volume Two: This Fair Land of Ours; Volume Three, Old Wilmington and the Greater in its March to the Sea*. (Two and Three in one volume). Wilmington, NC: privately printed, 1980.

Lee, Lawrence. *The Lower Cape Fear in Colonial Days*. Chapel Hill: The University of North Carolina Press, 1965.

Lennon, Donald R., and Ida B. Kellam. *The Wilmington Town Book*. Raleigh: North Carolina State Archives, 1973.

McKoy, Henry Bacon. *Wilmington, N.C.—Do You Remember When?* Greenville, SC: privately printed, 1957.

Moore, Louis T. *Stories Old and New of the Cape Fear Region.* Wilmington, NC: The Wilmington Printing Company, 1956.

Noffke, Jonathan. "The Civil War Years at the Bellamy Mansion." Bellamy Mansion brochure, March 1995.

Preik, Brooks Newton. *Haunted Wilmington, and the Cape Fear Coast.* Wilmington, NC: Banks Channel Books, 1995.

Reaves Collection—Block Files, Subject Files and Family Files. New Hanover County Public Library, Wilmington, NC.

Reaves, William M. *"Strength Through Struggle": The Chronological and Historical Record of the African-American Community in Wilmington, North Carolina, 1865–1950.* Wilmington, NC: New Hanover Public Library, 1998.

Sprunt, James. *Chronicles of the Cape Fear River, 1660–1916.* Raleigh, NC: Edwards & Broughton Printing Company, 1916; Wilmington Broadfoot Publishing Company, 1992.

————. *Tales and Traditions of the Lower Cape Fear, 1661–1896.* Wilmington, NC: Legwin Brothers Printers, 1896; Spartanburg, SC: Reprint Company, 1973.

Tetterton, Beverly. *Wilmington—Lost But Not Forgotten.* Wilmington, NC: Dram Tree Books, 2005.

Turberg, Edward F., and Christopher Martin. *Historic Architecture of New Hanover County, North Carolina.* Wilmington, NC: New Hanover County Planning Department, 1986.

Wrenn, Tony P. *Wilmington, North Carolina: An Architectural and Historical Potrait.* Charlottesville: University of Virginia Press, 1984.